Otafuku · *Joy of Japan*

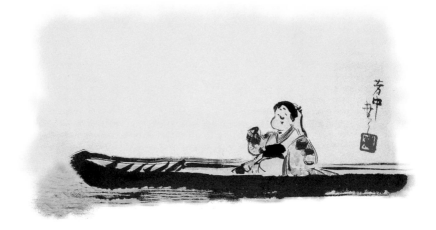

Otafuku · *Joy of Japan*

Amy Sylvester Katoh

Photography by Yutaka Sato

TUTTLE PUBLISHING
Boston • Rutland, Vermont • Tokyo

For Ruby Momo,
Okame reincarnate.

Published by Tuttle Publishing, an imprint of Periplus Editions (HK) Ltd,
with editorial offices at 130 Joo Seng Road #06-01, Singapore 368357
and 153 Milk Street, Boston, Massachusetts 02109.

LCC Card No. 2005920739
ISBN 0-8048-3364-8
ISBN 4-8053-0707-2 (for sale in Japan)

Printed in Singapore

Distributed by:
Japan: Tuttle Publishing
Yaekari Building, 3F, 5-4-12 Osaki, Shinagawa-ku, Tokyo 141-0032
Tel: (03) 5437 0171, Fax: (03) 5437 0755, Email: tuttle-sales@gol.com

North America, Latin America & Europe: Tuttle Publishing
364 Innovation Drive, North Clarendon, VT 05759-9436, USA
Tel: (802) 773 8930, Fax: (802) 773 6993, Email: info@tuttlepublishing.com
Website: www.tuttlepublishing.com

Asia Pacific: Berkeley Books Pte Ltd
130 Joo Seng Road #06-01, Singapore 368357
Tel: (65) 6280 1330, Fax: (65) 6280 6290, Email: inquiries@periplus.com.sg
Website: www.periplus.com

TUTTLE PUBLISHING® is a registered trademark of Tuttle Publishing.

Contents

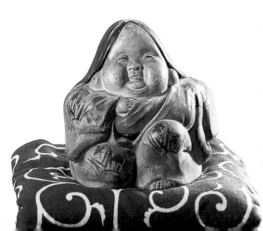

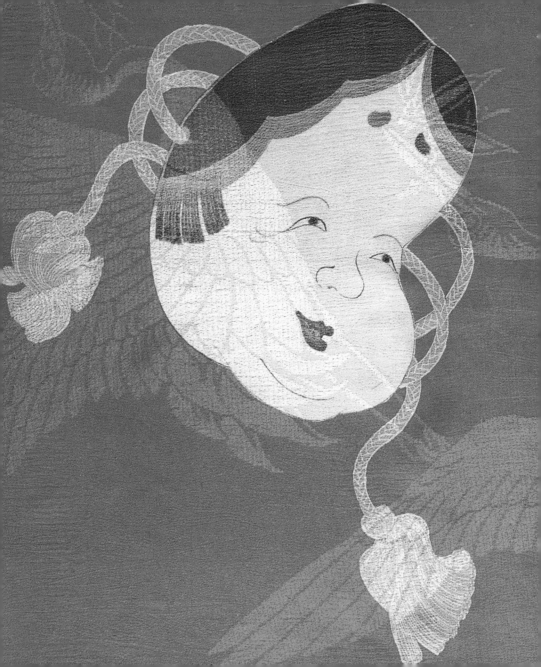

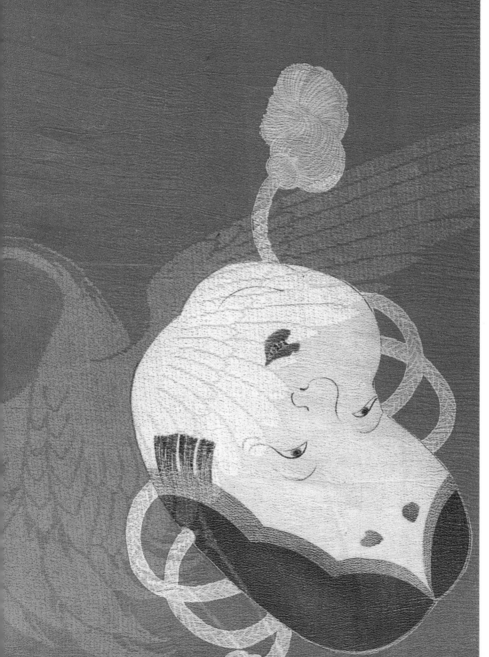

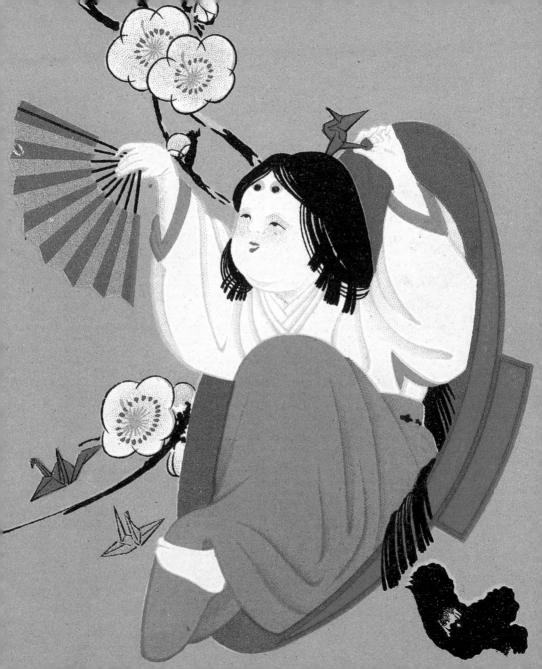

CELEBRATING LIFE

This book is about celebrating life, celebrating the everyday ceremonies of life—the quiet miracle of the sun's rising in the morning, its more spectacular setting, the new beginnings, new chances we are blessed with each day.

The opening of the shoji/curtains to greet the day; the first good morning; the first cup of tea, coffee, the first knee bend or stretch, a ritual sweep of the kitchen, reading the newspaper, watering the plants—the myriad moments that are part of the daily litany of life.

Think of them. They are a source of wonder, a reason for gratitude.

This book is about the little things that make our days flow. Our teacups, our towels, our toothbrushes, our dreams. Our families, our dogs, cats, bikes, our husbands, wives, friends, gardens, teachers, bus drivers, grocers, our itches, our pains.

This book seeks to honor the unsung everyday events of life and celebrate how they give our life shape and direction. While Otafuku smiles.

人生を祝う

日々の暮らしのなかにたくさんの幸せと喜びを見つけ、感謝して生きたい ―― そういう願いからこの本が生まれました。毎日、東から太陽が昇り、夕方には西の空を染めて沈む、当たり前のことですが、考えてみれば、実に有り難い恩恵です。

朝、窓を開け、新鮮な空気を入れ、おはようと言い、お茶をいただく、膝を屈伸してみる、台所をささっと片付け、新聞を読み、植木鉢に水をやる……。気持ちのよい朝は、幸せな一日のはじまりです。

日常茶飯事の積み重ねが生活を豊かに満ち足りたものにしてくれています。お茶碗、タオル、歯ブラシ、夢、家族、犬や猫、バイク、夫や妻、友人、庭、先生、バスの運転手さん、八百屋さん、そしてちょっぴり切ないことも……。

そんな当たり前のこと、ささいなこと、ひとつひとつをいとおしみ、ひとつでも多くの幸せを見つけ、感謝して生きる時、人生はいきいきと輝き、豊かになります。それを静かに微笑んで見ているのは ―― おたふくさん！

100 Faces of Otafuku

Life in Japan has taught me—among many other things—to believe in good fortune and bad and to see the wisdom in age-old beliefs that some call superstitions. I take Lady Luck seriously now and treat her with respect. When I first came to Tokyo in 1962, however, I was a cynical young thing in charge of my own destiny, thank you. So it was disconcerting to find myself in a world where traditional ways and beliefs were still largely intact.

In those days, I often encountered the image of a chubby lady in the entrances of houses, in corners of rooms, on packages, and on fortune papers at Shinto shrines. I was told that her name was Otafuku or Okame. Other than laughing at her silly face and noticing that she came in a host of shapes and attitudes—charming, coquettish, vulgar, cutesy, and downright ugly—I paid her little attention.

But as my years in Japan sped past, I began to see that there was more to the ancient rituals than meets the eye. Japan's native system of belief, with its devotion to gods and spirits and ancient ritual, gave order to the course of daily life. Forces of evil were quelled by regular ministrations to the forces of good. And these forces, always present but needing assuagement, were charged with bringing good fortune and happiness.

Otafuku has been part of this scene for a long time. She is not so much invoked as always there, overseeing the ups and downs of our everyday lives. Her smiling face takes away worry and brings joy. Her chubby cheeks and tiny red mouth suggest robust health and earthy simplicity. She makes us smile when we see her, even as she assures us that she has been watching over us and that everything is all right.

During my early years in Japan, I noted her presence. Now, I can feel her even before I see her. It happened when a friend introduced me to a new restaurant. I liked everything about the place—the design, the food, the presentation. Then, on the way out, a trip to the bathroom...and hanging over a small window in

the door, there she was, harbinger of good, a quirky little Otafuku mask. She has become a real friend.

This book has been brewing in my soul for a long time. Years ago, as an innocent—and ignorant—young college graduate, I came to Japan unaware of how radically my life would be changed. I have lived here now for longer than in my own country and have been the beneficiary of uncountable kindnesses as well as profound lessons in living. Like Alice, I entered a wonderland where people opened their lives and hearts and let me come in and feel at home. When I think of this, I suspect that certain forces have been steering me in the right direction, keeping me from harm's way. And that the lady in charge of it all has been Otafuku.

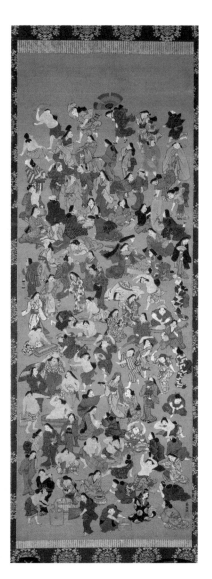

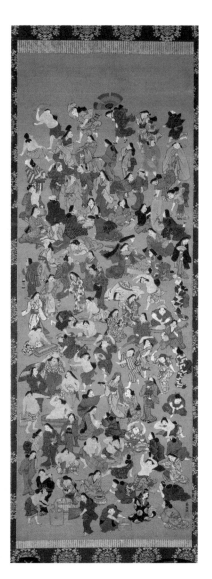寿ぎ | CELEBRATING • 13

おたふく百様

日本に住むようになって私はいろいろな事を学びました。

そのひとつは吉凶(きっきょう)に関わることです。迷信と人が呼ぶなかにも神秘が存在することに気がついたのです。1962年に私がはじめて日本に来た頃は、まだ若く生意気でしたから「自分の運命は自分で決めるから、ほっといてちょうだい」という気持ちが強く、古いしきたりや信心が根強くのこる日本社会に馴染(なじ)むのは大変でした。でも、時が経つにつれて心から幸運の女神の存在を信じ、敬(うやま)うようになったのでした。

家の玄関や、包装紙、あるいは神社のお札に人懐(ひとなつ)っこいぽっちゃりした顔の女性が描かれているのを見たことはありました。でも、それが「おたふく」あるいは「おかめ」と呼ばれる幸運の女神と教えられ、特別の関心を払うようになったのはずっと後のことです。彼女の表情は基本的には愛らしく、おどけた顔。でも時には色っぽかったり、えげつなかったり、かわいらしかったり、またはかなり見苦しかったり、と様々なのを見て、笑うだけでした。

何年かを日本で過ごし、はじめは単なる迷信だと取り合わなかった古いしきたりも、私の眼に映る以上に奥深いことではないかと考えるようになりました。吉凶は私達の日々の暮らしに深い関わりがあります、日本には、例えば凶とはいえども不吉の前触れを鎮(しず)めて福運に転じさせる民間の知恵が存在します。人々はあまり気がついていませんが、「おたふく」は昔から吉凶に関わり、私達の日常の生活を見守る役割を果してきました。

私達の日常の不安をとりのぞき、喜びをもたらすもの。それはおたふくさんの微笑(ほほえ)みなのです。ふくよかな頬、紅いおちょぼ口は健康なたくましさと飾り気のない素朴さの象徴であり、私達の暮らしを見守り、家内安全をもたらせてくれるものなのです。

私は日本に住みはじめた頃には、お多福がいれば目に止まりました。今では見る前に、彼女はそこにいると感じます。たとえば、お友達が素敵なレストランに連れていってくれます。はじめてのお店なのに美味しい食事も雰囲気（ふんいき）も私にぴったりだと思って、お手洗いに立ってみると……。窓際に小さなお多福の面が吊るされていて、私はとっても幸せな気分になるのです。「やっぱり、あなたはここに居て、私を見守っていてくれていたのね」

私はずいぶんと永い間、この本のことを心の中で暖めてきました。もう何年も前、大学を卒業したての私は無邪気で、深いことは考えずに日本にやって来ました。私の人生がそれからどんなに大きく変化するかなど、思いもよりませんでした。今では私の生まれた国よりも長く日本に住んでいることになるのですが、その間に数え切れないほどの方に親切にしていただき大切なことを沢山学んだのです。不思議の国のアリスのように、私は未知の国に入り込み、そこにいる人たちの豊かな人生と心にふれ、そして受け入れられ、第二の故郷を得ました。そんなことを考えていると、なにか自分を超えた力が私をまちがったところから遠ざけ、正しい方向へと導いてくれているように思われてなりません。その大きな力を操っているのがおたふくなのだと、私には思えるのです。

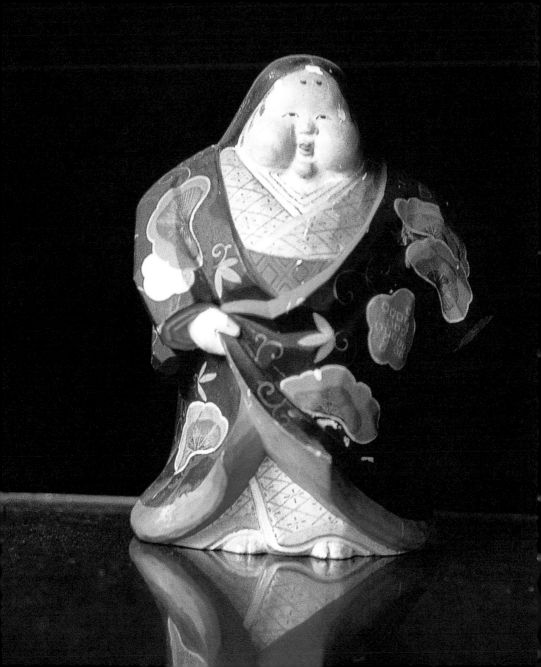

Who Is Otafuku?

She's not much to look at. She tends to be plump and frumpy, but something about Otafuku makes her the one you want to come home to. She's always there, waiting, with a smile and warmth in her heart. She brings jollity to any occasion and greets each new situation with laughter and bright-heartedness. She's fun and playful and open.

I love her. I have been drawn to her for 25 years! Somehow she has been beckoning, inviting me into Japan. Come explore the home and the hearth and the everyday life of the heart, she has been telling me. Come inside and play with me. Drink, eat with me, if you will. Let's chat and gossip. Open up and have a good time. Let's enjoy our lives.

I have always been drawn by interesting people. Hair out of place, maybe, hat askew, button forgotten, a twinkle of eye, a flashing smile. Someone different and warm and content with one's self and ready to laugh at the world and, most of all, flow with it.

My creed of imperfection, of enjoying human foibles and originality seems to be best embodied in Otafuku. She is my passport to the side of Japan that is not formal or ordered. She is different things to different people, but to me she is warm, cozy, loving, accepting. Her joyful attitude toward life is one we could all espouse and one that I aspire to myself. She is a universal goddess who bids us all know what is amusing in life and in other people. She is a fount of generosity, of sharing her own abundance.

「おたふく」さんってどんな人？

彼女はけっして美人ではありません。どちらかと言うと、時代遅れの愛嬌_{あいきょう}のあるぽっちゃり顔です。でも誰もが彼女の温かさや微笑_{ほほえ}みに接すると、一緒に居たくなってしまいます。どんな時でも明るく楽しく振舞い、皆を幸せな気持ちにさせてくれる、おおらかな福の神です。

私が彼女に魅せられて25年が過ぎました。私がこの日本にやってくることになった運命も、ひょっとしたらお多福さんが手招きしてくれたからかも知れません。日本に住みだして以来、彼女は何時も私のそばに居てくれて、一緒に食べたり、飲んだり、おしゃべりしたり、私と人生を楽しく分かちあってきたのです。

私は少し変わった人が大好き。髪はすこし乱れて、帽子は斜め、ボタンがはずれていたりしても、目がキラキラして笑顔いっぱいの人。そんな人って自分の人生が何であるかを理解していて、いつも世界にむけて微笑みをなげかけているでしょ？　私がお多福さんを好きになったのも、彼女の少しずれているけれど、個性と安らぎにあふれたおおらかな性格に魅せられたからです。

彼女は私に形式とか秩序_{ちつじょ}からちょっぴりはみだして日本社会をのぞくパスポートを与えてくれました。お多福を見る人々の目はさまざまですが、私にとって彼女は気の張らない心優しい存在です。彼女が楽しく人生にたちむかう様子は人々の共感を呼び、私にも人生の指針を与えてくれます。お多福さんはどこでも誰にでも惜しみなく人生の悦びを分かち与える、永遠の泉なのです。

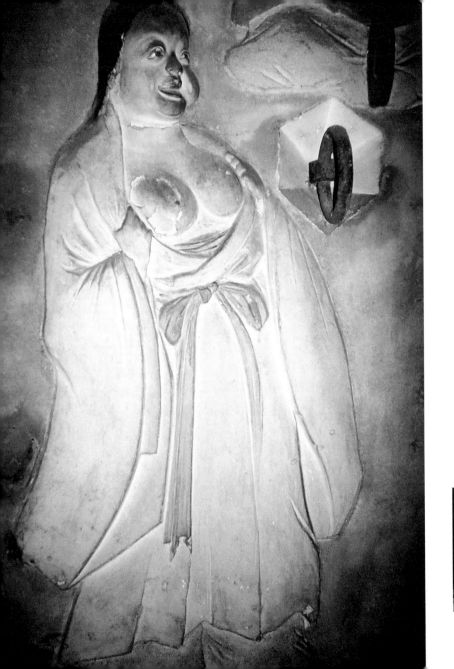

Otafuku* Origins

In the very beginning, the dance and laughter of a goddess did what masculine force could not—restore order to the world. The earliest chronicles about the founding of Japan show us the power of a woman's dance and humor.

The creation myths recorded in the *Kojiki*, Japan's "Record of Ancient Things," tell how Amaterasu Omikami, the Sun Goddess, angered by the violent pranks of her brother, Susano-o no Mikoto, hid herself in a cave and plunged the world into darkness. Chaos reigned. The eight million gods convened to decide how they could entice Amaterasu Omikami from the cave. They hung a mirror and streamers of plant fiber on a sacred tree, and Ame no Uzume no Mikoto, a good dancer, bound her head and her sleeves with vines, and then with leaves in her hands, mounted an overturned tub and stomped rhythmically on it. She went into a trance and pulled down her robe, exposing her breasts. The gods laughed uproariously at her humorous dance, and the Sun Goddess, curious to see what was causing the hilarity, peeped out of the cave. One of the gods was able to pull her from the cave back into the world while another deity placed a sacred straw rope (*shimenawa*) before the cave, making it impossible for her to return there. Thus light and order were returned to the world because of Uzume's comic dance.

In historical times, the daughters of provincial aristocrats were sent to Kyoto and trained as shrine maidens to dance and perform at sacred rituals. These girls came to entertain in semireligious performances in shrines throughout Japan. They wandered through the country in performing troupes, which were the ancestors of *noh* and *kyogen* and *kabuki* dramas, continuing the tradition of Ame no Uzume's entertaining dance. Some early *sarugaku* and *dengaku* masks representing Uzume no Mikoto were used for the dance. Other dance masks, portraying a strong-willed and somewhat plain woman, were called Otohime and Oto. Though there is no scholarly research to confirm my belief, Uzume's heir is surely Otafuku, otherwise known as Ofuku, Okame, Otan and Otayan. The names vary with the areas where the masks were made. In time the masks

came to exaggerate the ugly and the comical sides of her, so that the Otafuku we see today is a highly stylized version of Otohime. They still have the power to entertain and make people laugh. However homely, they all represent the same plain-featured soul who radiates goodwill and brings order and brightness to life. Her history is the history of Japan and has branches lost in the mists of local traditions and beliefs.

Uzume's basic primal strength, her pure and unsullied humor and goodness are all contained in the myth of saving the universe from darkness and chaos with courage and laughter. This strength transcends time and place and language. Goddess and dancer, sage and comedienne, protector of the sun and preserver of life, she is a universal archetypal female. She is the brightness and vital energy and mystery in the heart of all women.

What's in a Name?
* Otafuku and Okame today are different names for the same female figure as far as I have been able to ascertain. Whatever distinctions were once recognized have become blurred over the centuries. In this book the names are used interchangeably.

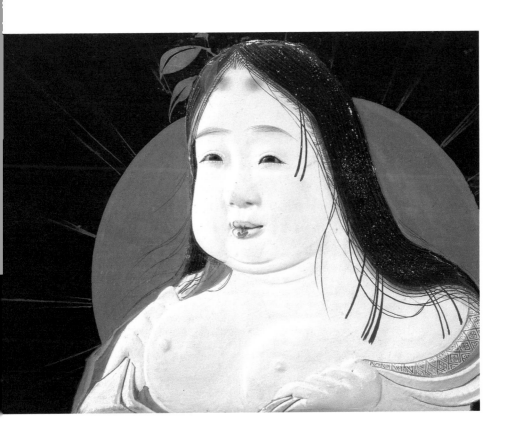

おたふくの起源

神代の昔、男神たちが思いあぐねていた難題をある女神が踊りと笑いで解決した話があります。

日本最古の歴史書である古事記の中にある天の岩戸の神話は、まさにこのウーマンパワーについて語っています。弟のスサノヲ（須佐之男命）の乱暴狼藉に怒ったアマテラス（天照大御神）が岩戸の奥に隠れてしまったので、全世界ことごとく闇におおわれました。困り果てたヤオヨロズ（八百万）の神達は高天原に集まり、なんとかアマテラスを岩戸から引き出そうとしました。

神々は岩戸の前の枝に鏡や青和弊と白和弊をつるし祝詞をあげ、女神のアマノウズメ（天宇受売命）が妖艶な踊りを舞います。伏せた桶の上で足踏みをして、小笹の束を手に踊るやウズメはやがて神懸かりの状態となり衣の緒を解き、乳房もあらわに踊り狂ったそうです。集まった神々がウズメの踊りに興奮して笑いどよめきました。隠れていたアマテラスは何事かと思い岩戸から出てきたところ、他の神が岩戸にしめ縄を張り、戻れないようにしたので、暗黒だった高天原に再び光が照り輝き、平和がよみがえったという神話です。

古代には、地方豪族の娘達は修行のために京都へ送られ、巫女として神に仕え踊りを奉納したと伝えられます。後にこの娘達が地方へもどり、神社で奉納される猿楽や田楽を演じるようになりました。時代がさがると、ウズメの踊りを継承する猿楽や田楽の集団は全国を行脚するようになり、後に能、狂言、あるいは歌舞伎を演ずる基礎を築いたと言われています。初期の猿楽や田楽ではあきらかにウズメの面が使用されました。その面はオトヒメ（乙姫）あるいはオト（乙）と呼ばれ、強い意志をもった不器量な女性の顔を表わしています。これは学問的に実証された訳ではありませんが、私はおたふくの祖先はウズメだと信じています。

おたやん、おたん、おかめ、おふくなど、その呼称は面が彫られた地域によっ
て異なっていますが、時代と共にその表情にはひらべったい顔やおどけた様子
が強調されるようになりました。そして今日私たちが目にする典型的なおたふ
くの顔は歴史を経て洗練されたオトヒメの顔であると指摘できるでしょう。現
代でもおたふくの面は神楽やお祭りにしばしば登場し、人々を笑わせ、人生に
喜びをもたらす象徴として大きな力をもっています。おたふくは時の彼方へと
忘れ去られた地方の信仰や伝統を今日に伝える使命を果たしてきたのです。す
なわち、おたふくの歴史は日本の歴史そのものだと言えるかも知れません。

ウズメの原初の力、真正の機知と善意がこの世を暗黒の混沌（こんとん）から救いだしました。このことは、言語や場所や時間を超越した女性の普遍（ふへん）の力を表しています。つまり、おたふくの持つ神秘性や生命力、明るさは全女性を代表するシンボルなのです。おたふくとおかめの区別は長い歴史のなかであやふやになってしまったのですが、私は同一人物の異なった呼び方であると思います。例えばひょっとこあるいは天狗と一緒に登場するときには「おかめ」と呼ばれますし、商売繁盛で知られる福助と相対する場合には「おたふく」の呼称がつかわれます。この本のなかでは、その呼称はその都度使い分けます。

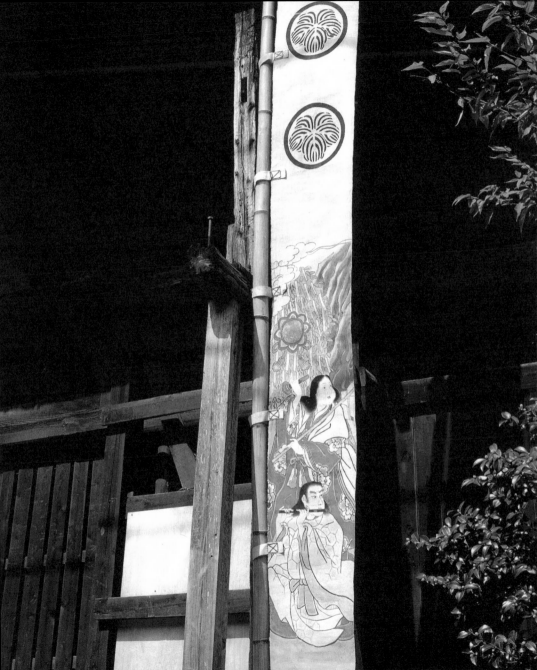

I borrowed the wayside shrine

from the fleas and mosquitoes

and went to sleep

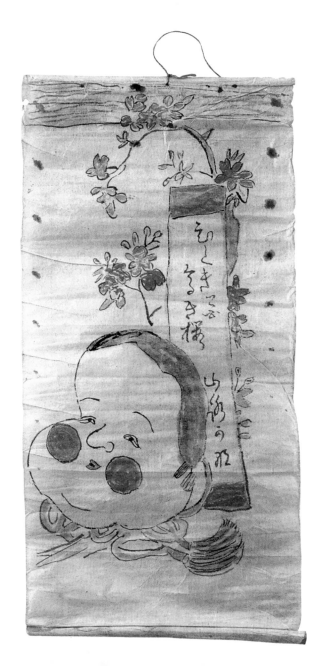

An Otafuku Blessing

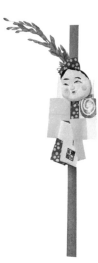

For days the diligent young women at my shop, Blue and White, had been making amulets— one is a small papier-mâché Otafuku face mounted on a slender bamboo stick, from which dangles a zigzag paper streamer decorated with a stamped spiral. A piece of dyed cotton and a sprig of rice completed the amulet. Another is little more than a small packet of handmade paper containing a ¥5 coin; the packet is stamped with a blue Otafuku face and tied over the head with a twist of indigo fabric. Felicitous symbols all.

But not quite enough, I thought, without a more direct heavenly endorsement. So my husband and I drove up to the quiet little Kumano shrine at the top of the mountain pass above our old farmhouse in the town of Karuizawa in Nagano Prefecture. Day was just disappearing into a misty evening. No one stirred in the charming old shrine at the top of a long stone stair. Only the two stone lion dogs greeted us at the bottom, one with a particularly foolish grin. We prayed earnestly, one of us on each side of the boundary between Gumma and Nagano prefectures, which bifurcates the shrine. We emptied our pockets of small change to throw into the offering box in front. We bowed and clapped two times to call the gods. But still no priest appeared. We finally located him at his house below the shrine. He invited us in and gestured that I place the good luck amulets on a footed lacquer tray. I did, and he instructed us to bow two times while he chanted. Then two claps. Or was it three? Deep in prayer, he waved his long wand of white paper streamers over the waiting Otafuku amulets and over us. He blessed us with all his power of prayer. I felt a shiver pass through me as gods and man were connected. Here at the beginning of the 21st century was a priest devoutly following customs that reached into ancient legend. And here, once again, was Otafuku at the center of things, shining her light, sharing her blessing.

We brought the amulets back to Blue and White for customers who wanted to share in good fortune well blessed.

お祓いを受けたおたふく

私のお店、ブルーアンドホワイトで働きもののお嬢さん達におたふくのお守り
を作ってもらったことがあります。その一つはうずまき模様のついた御幣がぶ
らさがった竹におたふくのお面を取付けたもので、ちいさな木綿の染布や稲穂
も飾りについてます。もう一つは小さなもの、青色のおたふくの顔が捺印され
た和紙に5円（御縁）が包まれたものです。これは藍染めの紐で括られています。

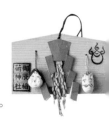

これらのお守りですが、私はこれだけでは十分ではない、さらに神の御加護が
欲しいものだと考えたのです。

長野県の軽井沢に私達の古い農家の別荘があります。霧の中に一日が終わろう
とするある日の夕暮れ、私達夫婦はこれらのお守りを持って、別荘の近くの峠
の上にある熊野神社を訪ねることにしました。長い石段を登り詰めたところに
あるちいさな古い神社はひっそりとしていて、迎えてくれたのは一対の狛犬で
した。

実は熊野神社は群馬と長野の県境に建てられています。そこで、私達はそれぞ
れ群馬県側と長野県側に分かれて立って、お賽銭をあげて、熱心にお祈りした
のです。二度、柏手を打ちならしたのですが、どうも神主さんは現れそうにあ
りません。でも私達は裏手の社務所に居られることをつきとめました。

事情を話すと、私達は招き入れられ、持参したお守りを漆塗りの三宝に置くよ
うにと指示されました。そして、祝詞を奏上するあいだに、二度おじぎをして、
二度柏手を打つようにいわれました。……三度っていわれたかしら？

深い祈りのなかでおたふくと私達の頭上で白い幣束が打ち振られ、神と人の神
聖な魂の交わりを感じて私は思わず身震いをするほど感動しました。もう21世
紀だというのに、ここでは一人の神主が古式さながらの作法にしたがって私達

を清めてくれているのだ、との思いがこみ上げたのです。

こうして熊野神社のお祓(はら)いをうけたおたふくのお守りは幸福と祝福をお客様と
わかちあえることを願ってブルーアンドホワイトに帰ってきたのでした。

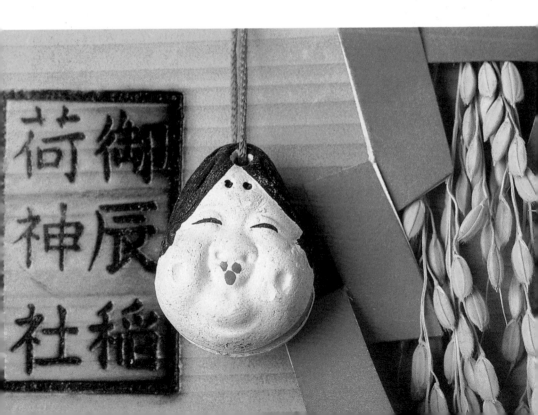

Otafuku Connections

Mayumi Oda, an old friend from Tokyo now living in Hawaii, is a wise and contemplative artist of exuberant goddesses. To reach her secluded house was an exercise in subtle intuition. No signs, just meandering dirt roads between crumbling lava walls and a long tunnel of plumeria trees leading to a clearing with a green-and-white plantation style cottage. Here was an enchanted garden where Mayumi, an artist and vegetable farmer, lives and farms and paints her distinctive voluptuous figures. We discussed her art, her gardens, and her goddesses over a soup of home grown vegetables. When I told her about Otafuku, she smiled and produced several books on the 18th century Zen priest Hakuin, whose incisive brushwork paintings were studies in, and metaphors for, enlightenment. There was Ofuku/Otafuku, captured by this wise man, sitting by the open hearth, grilling little round rice balls. With a silly smile, her cumbersome comb aslant in her hair, she waits alone for someone to come, waiting to give and to care for. A glorious embodiment of Otafuku, right there in a book I had never seen, by a famous artist I had not known! "And she will come to you," said Mayumi Oda, my artist friend, and she has.

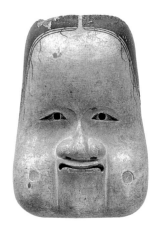

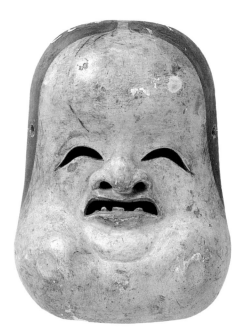

おたふく仲間

小田真由美さんは東京出身で、ハワイに住む私の古いお友達です。彼女はとっても豊かで華やかな女神を描く芸術家です。ハワイの人里離れた、白と緑のペンキで塗られた、お洒落なプランテーションスタイルの彼女のお家にたどり着くにはちょっとした勘が必要です。何故なら、崩れた溶岩の壁やプルメリアの木の長いトンネルをくぐり抜け、標識もない未舗装の曲がりくねった道路を走らねばならないからです。

彼女はこの魅力的な地に根をおろし、畑を耕し、官能的な女神を描いて暮らしています。彼女の菜園から採れた新鮮な野菜でつくられた美味しいスープを御馳走になりながら、芸術のこと、畑のこと、女神達のことと私達の再会のおしゃべりはつきませんでした。

お多福の話題になった時、彼女は数冊の画集を私に見せてくれました。それは禅の悟りの修練とその隠喩ともいうべき、白隠禅師の墨絵でした。

私はその画集の中に、この賢者によって描かれたおたふく／おかめの絵をみつけたのでした。それは微笑をたたえ、大きすぎると思える程の櫛を斜にかざして、囲炉裏で串団子を焼きながらだれか来る人を待つおたふくの姿でした。こんなに神々しいお多福の姿が高名な禅僧である白隠によって描かれていたとは……！私はこの画集を見せられるまで知りませんでした。

「きっと縁があって、そのお多福はあなたのところへ必ずいくわ……」と真由美さんはいいました。そして、それが現実となろうとはそのとき夢にも思わなかったのです。

Faithful courtesan
And square egg
Like moonlight
On the new moon night

If people of upper and lower classes
Live in intimate harmony and
Have a smile all the time,
They accord with the hearts of
Buddhas, gods, heaven and earth.
Protected by eight million Shinto deities, Brahmas.
Indra, Daikoku and Bishamon —
Demons and evil deities flee in every direction.
Free of disease, healthy, all people will live long
In a peaceful world.
Five types of grain will be harvested by them;
Their houses will be prosperous
And full of good children.

—Hakuin

Penetrating Laughter, pp. 20–21

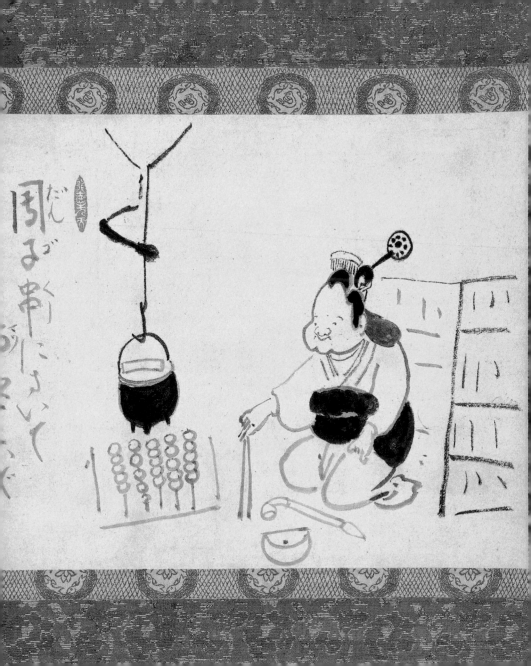

Hakuin

In 1685, not far from Mt. Fuji, Hakuin Ekaku was born in the village of Hara, in Suruga Province (now Shizuoka Prefecture). Even as a young boy, he showed precocious signs of intuition and insight and entered a Zen Buddhist monastery at age 14.

He studied Chinese poetry and art and used them in seeking to break through the barrier of ordinary thinking to enlightenment. He studied and used koans to try to reinvest Zen Buddhism with its original vitality and is famous for his "sound of one hand clapping" koan. He remained abbot of a small rural temple for most of his life and attracted a number of disciples. Hakuin did not start painting until his mid fifties. His painting reflects the power and intensity of his thinking and beliefs. Through folk images and songs and jokes, he sought to reinfuse a calcified Buddhism with new vitality. He spoke in the language of the common people and used such folk themes as Otafuku often in his paintings. Kazuaki Tanahashi, in his book *Penetrating Laughter* states that Hakuin invoked "this funny-looking woman" as one of his messengers to teach the precepts of Zen and that he likened her to an incarnation of Kannon, the bodhisattva of compassion.

Between 81 and 83 he was "exuberantly productive" in his art. He died in silence at the age of 85 in 1769.

白隠

白隠慧鶴は貞享二年（1685）駿河の国、現在の静岡県の富士山をのぞむ原という村に生まれました。幼少の頃より直感と洞察力に優れていた彼は14才で禅の道に入りました。白隠は中国の詩画に造詣が深かったのですが、実際に彼が絵を描き出したのは50代も半ばを過ぎてからでした。それは民衆に禅を説くという彼の深い思想と信仰に裏づけされており、多くは民間伝承やざれ歌を画題にした力強いものでした。彼は常にやさしい言葉で民衆に語りかけ、彼の絵にはしばしば民間信仰のおたふくも登場しました。

棚橋一晃はその著書『Penetrating Laughter』のなかで「白隠が画題に、敢えてこのおかしく見える顔の女性、すなわち、おたふくを登場させたのも、彼がおたふくを慈悲観世音菩薩の化身として民衆に禅の公案を解り易く説く使者として選んだのだ」と述べています。

81才から83才にかけて白隠の画業はもっとも高い境地に達し、明和5年（1768）に85才で入寂しました。

天ぐらくごはしておくなき

てんの午さわうまふ山

數ものを殿ばり～ひし

人をうかけまことかず～けし

命いゑつともはかりしをひゝれそ

はうゑいことくゝとものも

龍ひしく殺とといひさわれ

よんの殺といひさわれ

女の數とも遠しほまてゝ

けよ～る～われれいゞや

暑帚し～じと～参ちゃ山

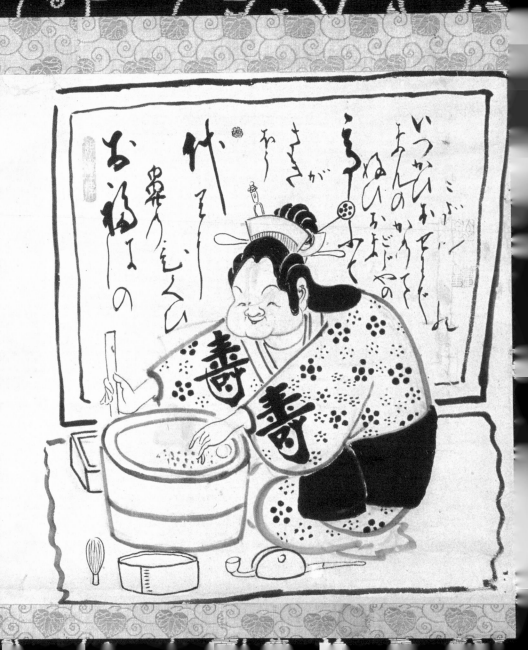

A REAL OKAME

At Senbon Shakado, an old and quiet temple in Kyoto, the "real" Okame sits under a red umbrella and smiles. She is a recent rendering in bronze of an historical woman. Senbon Shakado is said to be the oldest Buddhist temple in Kyoto. A leaflet published by the temple relates that Okame was the wife of the master carpenter who built this temple in the year 1227. When her husband cut the principal column of the building too short, he desperately asked his wife for advice. She prayed for divine guidance and came up with a clever solution to her husband's dilemma, which saved the construction of the new temple. In gratitude, she gave her life. Her husband hung her image on the roof beams, and this practice of hanging an Okame mask with a circle of three open fans on the roof beams of a new building has been followed by some carpenters and construction companies ever since.

We found Okame quite by chance. I had gone with friends on my second annual visit to Kyoto at the coldest time of the year. Our purpose was simply to participate in Setsubun, February 3, the ritual of banishing the Bad and welcoming the Good (Fuku). We had completely immersed ourselves in those ancient beliefs. Our itinerary was only partially planned. The owner of our inn happened to suggest a few places to visit. Was it just by fluke we stopped by Senbon Shakado and had a chance to see the kneeling Okame statue, larger than life, holding a peach and smiling over the temple compound?

She was waiting for us in that ancient temple just at her big moment once a year when hardy mountain priests, wearing Okame masks on the back of their heads, parade along with the temple elders and people born in that year of the animal zodiac. They throw beans and welcome in good fortune. We were truly blessed by having found her and were dazzled by the display of hundreds of Okame figures in the temple's collection donated by believers. And we took her home with us in the form of masks and other Okame figures we bought at the temple. Her spirit continues to watch over us and keep us well.

実在したおかめ

京都の静かな古いお寺に本物のおかめはいました。そのお寺には歴史上の人物を祀って昭和54年（1979）に立てられた、赤い日傘の下でひざまずいて笑いかけるおかめの銅像があります。このお寺の名前は千本釈迦堂と呼ばれ、京都で最古の建築として知られています。

釈迦堂は鎌倉時代中期、安貞元年（1227）に建立されました。実はこのおかめの像は、このお寺を建てた大工の棟梁の妻の霊を慰めるために祀られたものなのです。ある日、棟梁は大黒柱になる大切な柱の一本を間違って短く切ってしまいました。困りはてた棟梁は妻のおかめにこのことを打ち明けました。

おかめは釈迦如来に自分の命とひきかえに解決を願いました。夢の中で柱に組物を作って足せばよいとのお告げがあり、棟梁は仕事を見事に成就、おかめは我が身の献身により、夫を救ったと伝えられれいます。棟梁が亡き妻を偲んで梁におかめの面を祀ったことに倣って、今日でも上棟式に使う式具として弊串におかめの面をつけるところもあります。

千本釈迦堂のおかめとの出会いは偶然でした。節分の行事を楽しみに友達を誘って厳寒の京都へ行きはじめて二度目の冬のことです。古代から続く鬼やらいを見物するのが主な目的でこまかいことは決めてなく、宿の主人からいくつかのお勧めを教えてもらって、あちこちとめぐり歩きをました。千本釈迦堂の門前で足をとめ、境内にふと目をやるとなんとおかめの銅像が見え、桃を手にして私達に微笑みかけているではありませんか。それは単なる偶然だけではなかったと思います。歴史的な京都の寺で、年に一度の節分の行事がおこなわれるこの日に、彼女は私達の訪れを待っていてくれたのだと考えずにはいられません。

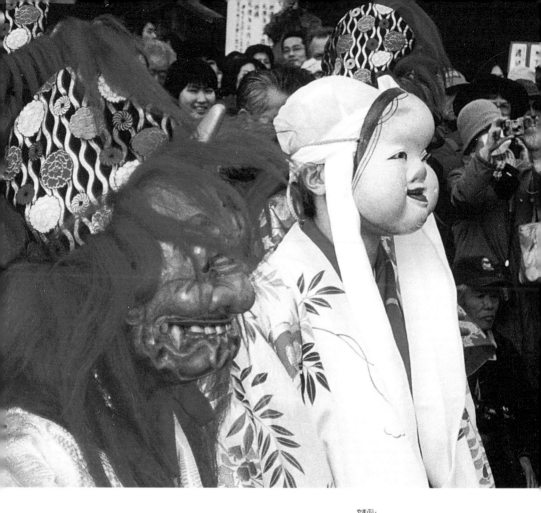

この日、釈迦堂ではおかめの面を後ろ向きに付けた山伏の行列、長老、その年
の歳男をはじめとする氏子によって豆まきの厄よけの行事がおこなわれます。
実在した釈迦堂のおかめと出会ったことで私達は新たな祝福を受けたのでした。
私達は信者達によって奉納された数多くのおかめのコレクションに目をみはり、
おかめの福にあやかりたいと願い、釈迦堂のおかめの面やお守りを手にして家
路についたのでした。

Okame Worship
(from an explanation sheet given out at Senbon Shakado temple)

"Okame assures that failure always becomes success, that misfortune becomes good fortune, that one's heart's desire will be accomplished. She helps to see that wishes will be granted. This is why Okame is called Otafuku ['Much Felicity']. In this temple we supply a Daruma doll with an Okame face, which returns upright immediately if pushed over, an Okame gohei [a wooden wand with paper streamers and an Okame face], and an Okame mask that will bring you luck. Those who receive these Okame items will make efforts to fulfill their desires, and those who have seen their desires come true will bring back these items as a prayer for happiness.

Please hang three Okame masks in your house, one in the entrance, one in the living room, and the other in the kitchen. The one for the entrance will calm the mind of visitors and give you a warm welcome when you return home. The one in the living room will make conversations between the family and visitors warm and happy. The kitchen is the core of life. If you watch Okame's smiling face, you will find peace of mind. We hope you will invite the heart of Okame into your life and avoid misfortune."

At Senbon Shakado temple a wondrous interaction of history and myth can be observed. That magical confluence of folk belief and divine intervention gives permanence to legend and credibility to objects of prayer and faith.

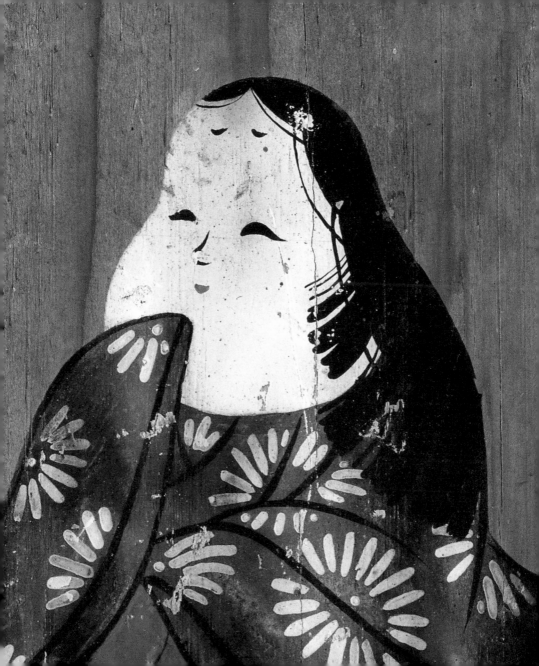

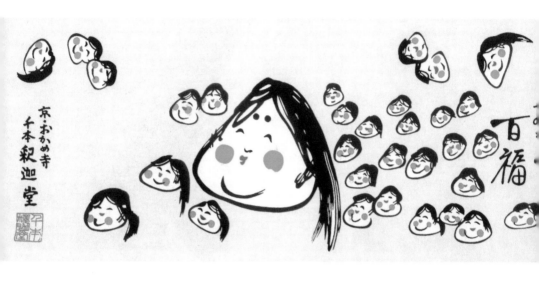

京・おかめ寺
千本釈迦堂

百福

おかめ崇拝

(千本釈迦堂の資料より)

『おかめは厄を除け、失敗を成功に導き、災いを福に転じさせる偶像として崇められてきました。またよろづの福を招くことからおたふく／お多福とも呼ばれています。京都の千本釈迦堂では古くから「おきあがりおかめ達磨」、「おかめ御幣招福お札」、「おかめ招福面」を信者に授与してきました。これらのおかめを祀った信者のあいだでは願いが成就すると、釈迦堂にお礼のお参りをして、古いお守りを奉納すると、いっそうの福がもたらされると伝えられています。

あなたの家に三つのおかめ面をお飾りしてください。一つ目はお玄関です、これは訪問者に安らぎを与え、帰宅するあなたをやさしく迎えるためです。二つ目はお座敷に飾りましょう、これは来訪者やあなたの家族に福をもたらします。三つ目はお台所、台所は生活の中心の場であり、おかめの笑顔は主婦の貴方にやすらぎと平常心を与えてくれるでしょう。おかめの心が家門を繁栄させることを願っております。』

千本釈迦堂にまつわる逸話には、その歴史と人々の言い伝えが絶妙に混ざり合っている様子が伺えます。民間の伝承と宗教的教えが合体することで、言い伝えは普遍の重みを加え、人々のおかめに対する信仰を強くしているように思えます。

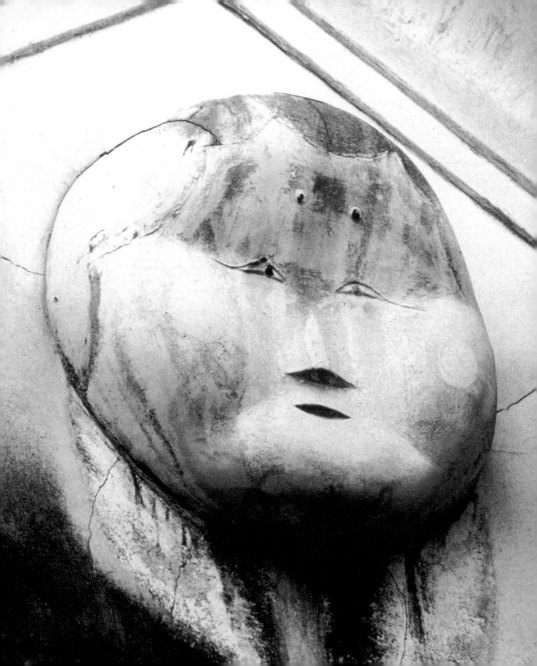

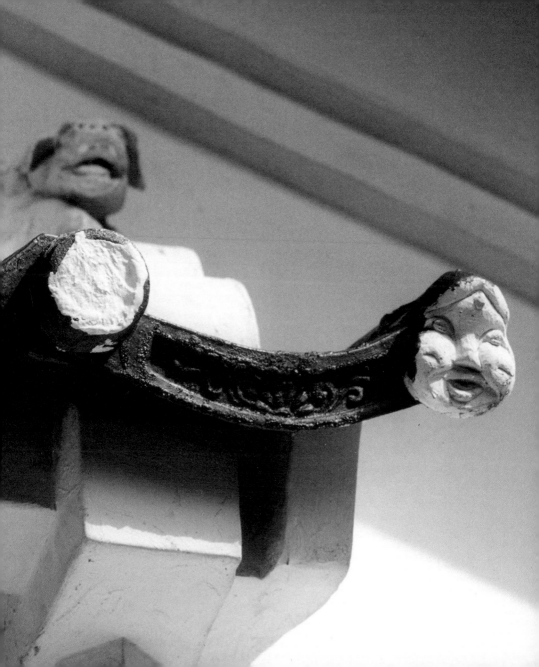

Of Heaven and Earth

Okame is a busy lady! I can't keep up with her. In Okame terms, Japan is a large country indeed. I continue to uncover new places, observances and rituals in which she is present, as well as confections and commodities to which she lends her power and grace. Her world continues to expand, and I see no end to it.

Okame stars in annual observances to banish evil, to mark the New Year, in rites of fertility and planting, summer festivals, harvest festivals, and fairs where good fortune charms are sold. She appears in *kagura* (sacred dance-drama) and *kyogen* (both sacred and comic drama) performances throughout the year as well as in formal Japanese dance. And she has different partners: Hyottoko is a somewhat foolish male counterpart; as Otafuku she is paired with Fukusuke, a masculine figure whose name also means "good fortune" (*fuku*), and sometimes she appears with the *tengu*, the long-nosed goblin figure.

Her role as bringer of good fortune is highlighted at the madcap Tori no Ichi markets in eastern Japan, where decorated bamboo rakes are sold. Such rakes, called Kumade ("Bear Paws"), are believed to gather prosperity and good fortune and often have plastic Okame masks as centerpieces. Some are huge, larger than a person can easily carry, some tiny enough to fit on the dashboard of a car. Following the philosophy that more is better, the rakes are stuffed with every possible good luck symbol and image—cranes, bamboo, plum blossoms, pine branches, gold coins, carp, sprays of rice stems…and each vendor's rakes are his signature in style and design. The Tori no Ichi fairs are held on two (sometimes three) days in November. The energy of these fairs is unforgettable; so is the crush of people. The rhythmic claps of vendors and buyers that celebrate a successful negotiation add to the noise and excitement. The Okame Fair in December at the Hikawa shrine at Hatogaya in Saitama Prefecture is a follow-up to the grand Tori no Ichi at Otori Shrine in Asakusa and anticipates the celebrations of New Year.

Just when I think I have mastered Okame geography, she emerges somewhere else, bringing vitality and radiance to the yearly calendar of Japan. She is found in so many guises—from crackers to Zen painting, from classical dance to village fertility rites. She is everywhere and anywhere, like the air we breathe. People take her benevolent presence for granted, so long has she been woven into the fabric of Japanese life.

She is the goddess who touches both the sacred and the profane. Dancing joyfully between heaven and earth, between the divine and the human, she is of both kingdoms. Like Uzume before her, she entertains man and gods alike and makes them laugh. Her power and presence show no signs of waning. An open mind and heart will find her around unexpected corners.

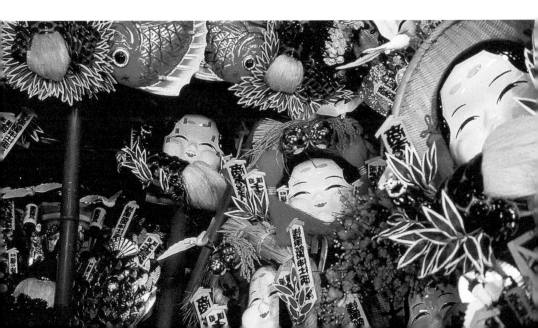

天と地

おかめは忙しい女性です！　彼女は儀式やお祭りに登場したかと思えば、お菓子や日用品のなかにも取り上げられています。私はそんなおかめの姿を求めて、日本全国を歩き回っているのですが、その世界は広がるばかりでとどまるところを知りません。追っかけの私は彼女に振り回されていることを告白せねばならないのです。

魔除け、年の瀬市、夏祭り、豊穣祭（ほうじょうさい）、収穫祭（しゅうかくさい）、骨董祭（こっとうさい）、おかめは四季を通して日本人の暮らしの色々な場面に登場して主役を演じます。私達は狂言や神楽（かぐら）、あるいは日本舞踊のなかにも、その姿をみることができます。しかし、おかめが最も輝かしい存在を発揮するのは、何といっても熊手が売られることで有名な関東の酉の市（とり）でしょう。真ん中に大きなプラスチックのおかめが飾られたこの熊手は繁栄と幸運をかき集めるお守りとして人気があります。この熊手は人が抱えられないほど大きいものから車のダッシュボードに飾れるほど小さなものまでいろいろなタイプがあります。縁起物（えんぎもの）が多ければ多いほど、大きい幸せを呼び込むことができるとあって、それぞれの露店は技（わざ）をこらした鶴、松竹梅、千両箱、鯉、稲穂といった吉兆（きっちょう）のシンボルで飾り立てます。

酉の市は11月に2回あるいは3回開催され、その賑わいと混雑は大変なものです。露店商と買い手の間で値段が決まると、習わしによって、威勢のよい手締めが鳴り響き、それがこの市の喧噪と興奮を盛り上げるのです。酉の市に続いて師走の年の瀬には埼玉の鳩ヶ谷にある氷川神社でもおかめ市が開催されます。

日本の何処にどんなおかめが存在するのか、私はもうほとんど知り尽くしたかにも思うのですが、なかなかそうはいきません。彼女はめまぐるしく次々と姿を変えて、私の前に現れます。お煎餅から禅画にいたるまで、あるいは神聖な奉納舞から村の収穫祭まで、私達が特別注意をはらわないありふれた日常の暮

らしの中に織り込まれ、空気のような存在で私を魅了し続けるのです。彼女は
まさに天上と俗界をむすぶ女神であり、楽しそうに天と地に舞い、神と人間を
寿ぐのです。かつておかめの前身であるウズメの踊りが、古代の神々に笑いを
もたらしたように、長い歴史を経た現代社会においても、おかめは私達に元気
と笑いをもたらし続けてくれます。

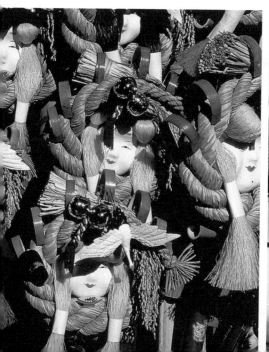
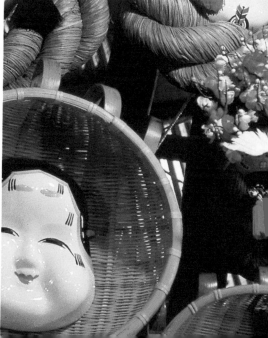

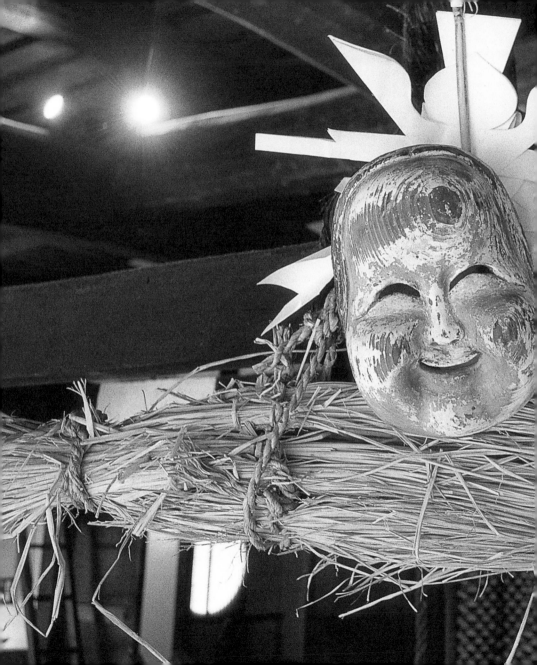

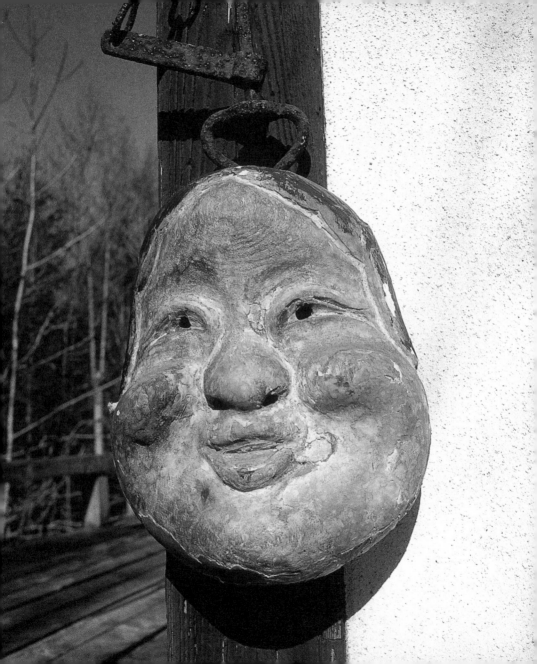

The dawn of the day—

the color of the sky

Is changing clothes

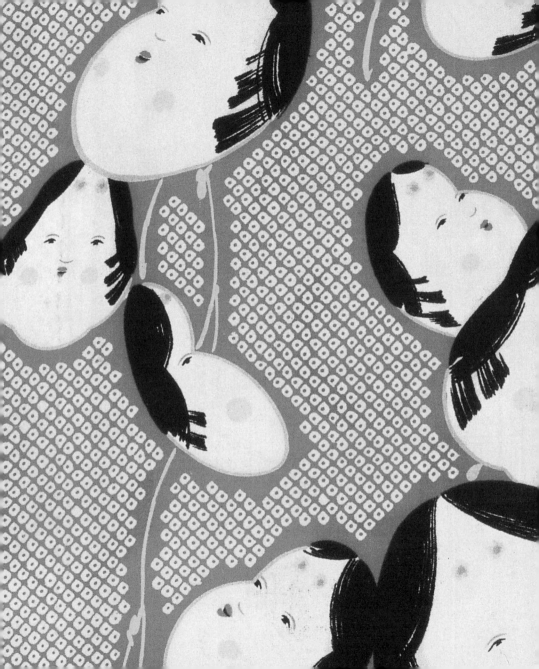

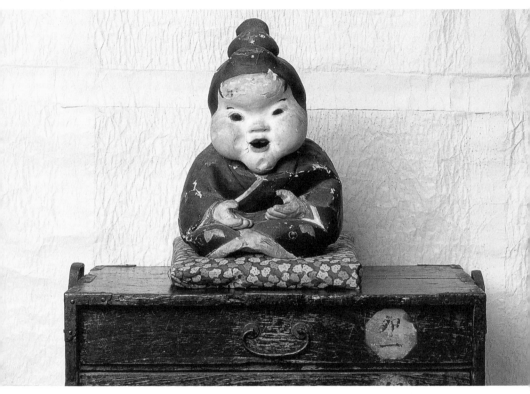

OTAFUKU ENCOUNTERS

Trying to organize our farmhouse kitchen in the still dark hours of a summer morning after the collapse of a long-trusted refrigerator, I came upon eight small reddish-brown spouted dishes. Just big enough for an individual serving of sauce or pickles, they were filled with the memory of an enchanted photo shoot in Okinawa for a glossy magazine. I had been invited to show my favorite places in Japan. Of course, the star was the crafts and particularly the pots, those rough, living objects still redolent of earth. They were the main focus for this photo session, and we were featuring Seisho Kuniyoshi, a brilliant and eccentric, primal potter whose pots climbed straight from the earth, having passed swiftly through his hands and then briefly through the chambers of his earth-covered climbing kiln.

It was my first meeting with Kuniyoshi, but I loved his obstinacy, his stubborn resistance to trend, his fierce pursuit of his own way. I was moved by the unafraid, unadorned honesty of his work. His sheds were rough structures of four upright logs with shelves struggling to hold his heavy pots, all functional, brown, massive forms. But wait! Over there in a dark corner, behind the plates and bowls, there was a familiar form. A fat, rough, greenish face with the familiar laughing eyes and a small mouth. Okame! Here in the sheds of Kuniyoshi, of all places, of all people—this thorny individual, a recluse who prided himself on his eccentricity, on his primitivism. Even here I found her! Seeing my thrill, he thrust her in my hand and bid me take her.

Six weeks after the interview, Kuniyoshi died. The shock was devastating. His Okame still sits over my desk and watches me quietly from a corner, and when I use the small spouted dishes I think of Kuniyoshi and remember the wonder of a visit to his organic kiln, like a visit to the beginning of all time.

As Okame was somewhere deep in his own deep recesses, she is also in ours, in our least expected places, this goddess waiting to issue from within and guide us through the dark. Maybe I should have left his muse of good fortune with him. I still wonder.

おたふくの出会い

ある夏の日、私達が長年愛用してきた別荘の冷蔵庫が突然動かなくなってしまい、大慌ての私はまだ暗いうちから起き出して、台所の片づけをしていました。すると赤茶色の八枚の小皿が私の目を覚ましてくれたのです。

そう、このお皿には私の沖縄での思い出がたくさんつまっているのです。国内の好きな場所をとりあげてレポートして欲しいという出版社からの依頼をうけて、沖縄のクラフト、それも陶芸を主にとりあげようと思いたち、沖縄在住の陶工、国吉清尚さんに焦点を絞って取材することに決め、沖縄に飛んだのです。この頑固で実直な陶工の手によって、登り窯から生まれる陶器はまるで大地からの贈り物のような壮大な味わいがあります。私はこの取材ではじめて国吉さんにお目にかかったのですが、流行に屈しない制作姿勢や正直で飾り気のない仕事ぶりに、すっかり虜になってしまいました。

国吉さんの仕事場にはがっしりとした荒削りの四本柱があって、棚には重たそうな茶色の陶器が棚板もしなわんばかりに並んでいます。そのどれもが機能的で存在感がありました。そしてふと皿や鉢が雑然と置かれた薄暗い仕事場の片隅を眺めた時、私の目はまさに釘づけになったのです。それはお馴染みのふっくらした頬、おちょぼ口、笑いかけてくるやさしい目。私の目に飛び込んできたのは、素朴で一徹なこの職人の手になるおたふくでした。あまりにも興奮した私の様子を見ていた国吉さんは、私の手のなかにこのおたふくを押し付け、「もっていきな」と言ったのです。

このインタビューから6週間後に国吉さんはお亡くなりになったのです。ショックでした！ほんとうにショックでした。あのおたふく皿は今も私のそばにあって私を静かに見つめています。このおたふくを見るたびに国吉さんのことを思い出し、彼の窯を訪ねて沖縄に取材にいった旅があざやかに脳裏によみがえるのです。

私にとっても、国吉さんにとっても、おたふくは意識しない深いところに存在
していて、私達の人生を導いてくれたのかも知れません。この幸運の女神を頂
戴しないで、国吉さんの手元においておくべきではなかったろうか……。いま
でも時々、私は自分に問いただしてみることがあります。

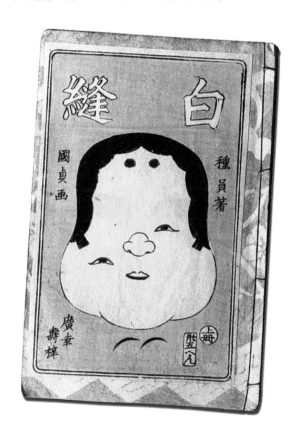

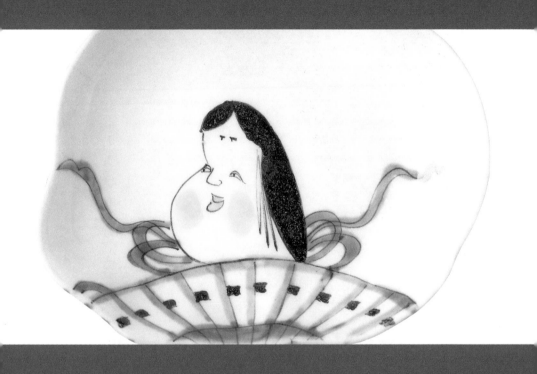

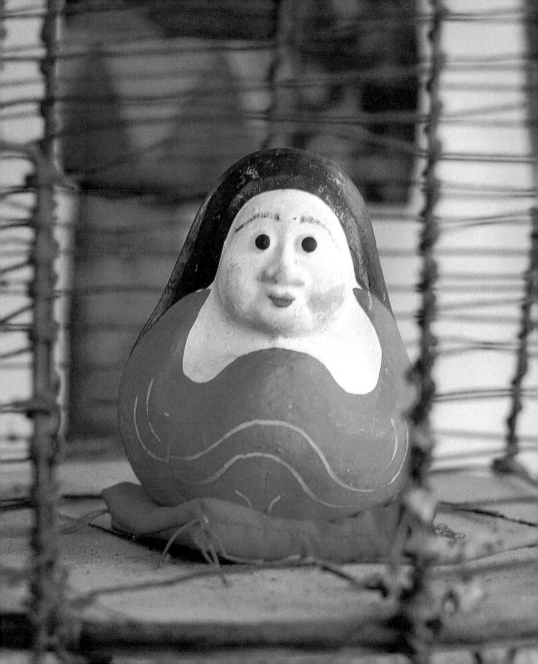

The bird in the cage

looks enviously

at the butterfly.

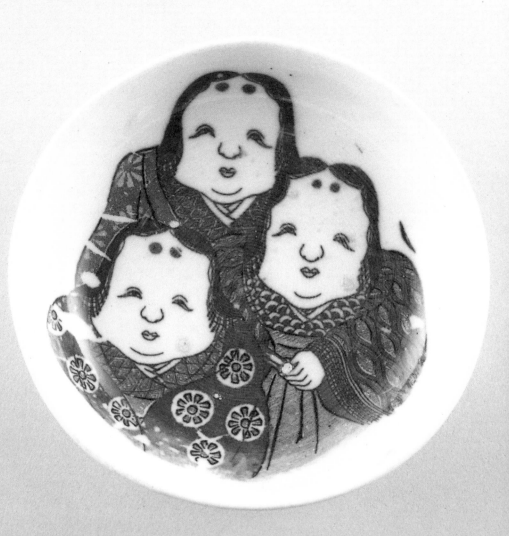

A Visitation

It happened again tonight. She came! A visit to Blue and White from two friends—one older, one newer—an afternoon visit stretched into dinner, and we repaired to a yakitori shop run by a charming and colorful couple. Talk swirled among women who hadn't met for twenty years—around our lives, children, jobs, flying, hiking, swimming, computers, textiles, quilting, education for the blind, theater…a churning mix of individual fascinations. Suddenly, immersed though I was in the conversation, my eye was caught by the serving dish on which the skewered bits of chicken had been delivered. There she was! A familiar line, a familiar contour. Look! It's her cheek! That was all there was left. A strong black curved line, a mass of hair. Two dots below the hairline. The rest of the face had vanished with constant washings and servings. And only the vaguest outline remained. But her presence was unmistakable. "Here I am!" she cried. "Watching over you, joining your fun. I'm behind you, blessing you and bringing levity and laughter, as if you're not already having enough."

The evening was just that—a warm and enlightening reunion of kindred spirits, with talk of others of the sisterhood and memories that raced back thirty years. We three were reaching out and learning new languages, gleaning new wisdom, reconfiguring what we had learned into new forms, instinctively charting maps, psychological and practical, for how to proceed. And Okame was with us, overseeing, listening, guiding our coming together. She led us on, inspiring us to connect and share and teach, laughing all the while. Get it all in and open yourselves so the connectedness nourishes and inspires you and leads you to new places and new opportunities, she urged.

友の訪れ

ブルーアンドホワイトに私の古い友人がひとりのお友だちを連れて遊びにきて
くれました。私にとっては彼女とは20年ぶりの再会です。昼下がりからはじまっ
た、女どうしのおしゃべりは尽きることなく、気がつくと夕方になってしまい
ました。そこで私達は近所の感じの良い若夫婦がやっている焼き鳥のお店へと、
繰りだすことにしたのです。

生活や仕事、子供のこと、海外への旅、ハイキング、水泳、コンピュータ、染
織やキルトのこと、視覚障害を持つ人達への教育、劇場めぐり……私達をとり
まく話題は尽きませんでした。そして、会話に夢中になっていた私は突然ハッ
としました。私の視線は焼き鳥がのっているお皿に釘づけになったのです。な
んと彼女がそこにいるではありませんか！ おなじみの線や輪郭、ほっぺた、強
く黒い曲線、黒々とした髪、おでこの二つの丸い眉。そのお皿は長年使いこま
れて、絵付けはすりへってぼんやりしているけれど、それはまさしく私が大好
きなおかめの図でした。

「私はずうっとあなた達と一緒にここにいたのよ。あなたの友人達との再会を祝
福していたのよ」と彼女はあたかも私に語りかけているようでした。

その夜は特別でした。姉妹のように仲良く、気のあう仲間と楽しく過ごし、30
年におよぶ旧交を温める同窓会となりました。私達の絆は深く結ばれ、新しい
未知の世界へと彼女が誘い出してくれたのです。

この楽しい夜は、いつも私のそばに居てくれるおかめさんがもたらしてくれた
のだと信じています。

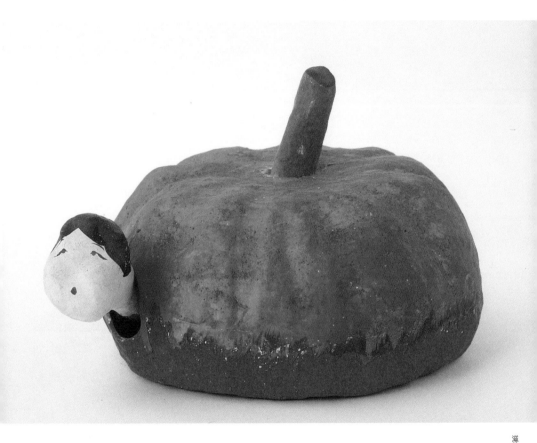

THE TASTE OF OKAME

Japan has a charming way of dividing people into basic types—not short and tall, fat and thin, athletic and intellectual, but sweet eaters and tipplers. Sweet eaters linger in bakeries and sweet shops and enjoy browsing chocolate counters. Tipplers relish the first foamy swig of beer. They savor volcanic warmth of whiskey, the aroma of sake before and after the first sip, and prefer salty or piquant snacks to sweet.

But Otafuku makes no distinctions. She watches over both predilections with equal care and graciousness. Her face enhances the shapes of confections, both sweet and salty, their paper packaging, and porcelain serving bowls and tiered boxes. She smiles from the bottom of sake cups, from sake pourers, bottle labels, and kegs. She is the mother, companion, wife, confidante we all seek in our own enjoyment of the delicious things in life.

The plum (*ume;* Japanese apricot) blossom is associated with Okame. She is depicted dancing with sprigs of *ume* blossoms, and the blooms often decorate her robes. Like her, the *ume* tree is jubilant and colorful. Its flowers bloom when winter is coldest. The fruit—dried, pickled, soaked in honey, as the basis of that wonderful cordial known as plum wine—is the source of delectable flavors to delight both the sweet eaters and the tipplers of this world.

PLUM WINE (*Ume-shu*)

Wash and pat dry 1 kg flawless green plums. Place in large jar and cover with 1.8 liter 35% *shochu* or other strong neutral spirits; then add about 600 gm to 800 gm rock sugar. Store in a dark place for at least one year; *ume-shu* matures well.

おかめは両刀遣(づか)い

日本では背が高いか低いとか、太っているか痩せているかとか、動的か知的かとか、そういう区分とは少しちがう感覚で、甘党か辛党かというチャーミングな見方が存在します。甘党はおしるこやあんみつが大好きで、ケーキのお店をいつもうろついている人達。辛党はお酒が好きで、ビールをぐいぐいと飲み干すことを無上の喜びとする人達です。彼らは強いウイスキーや日本酒の香りを楽しみつつ、辛いおつまみを酒の友とするのです。

しかしおかめは甘党の味方でも辛党の味方でもなく、どちらの人達にも好かれています。甘いお菓子にも塩からいお菓子にもおかめの顔を形どったものが多くあります。またそれらのお菓子のパッケージや磁器の入れ物のデザインのモチーフにもおかめが度々使われます。盃の底やお銚子(ちょうし)、酒壜(さかびん)や酒樽(さかだる)などいろいろなところに描かれた彼女は私達に笑いかけるのです。彼女は甘党、辛党を問わずおいしいものを楽しませてくれる人生の仲間と言えましょう。

梅とおかめは深い縁で結ばれています、梅の模様の着物を着た彼女が梅の枝を手に踊る姿はしばしば絵画にも登場します。梅花(ばいか)はおかめのごとく華やかで、冬もまだ寒い時期から高貴な香りを漂わせます。梅の風味は甘党辛党の両方から愛され、この一本の木に実る梅はそれぞれの好みにあった調理法で、私達にバラエティーに富んだ味の楽しみをもたらしてくれます。

梅酒

1) 形の良い青梅1キロを良く洗って水気をきる。

2) おおきな壜に入れて1.8リットルの焼 酎(しょうちゅう)を注ぐ(他の焼酎に準ずる強いお酒でも良い)。

3) 600~800グラムの氷砂糖を入れる。

4) 冷暗所に少なくとも1年おくと熟成する。

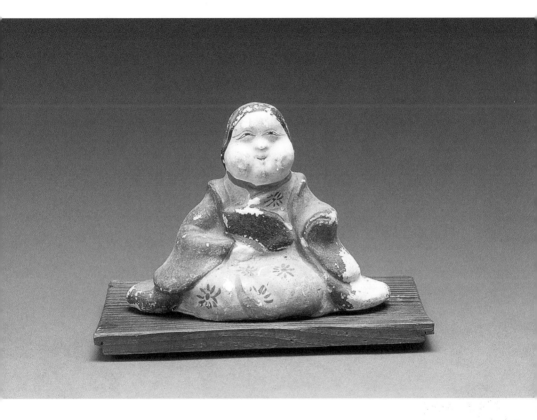

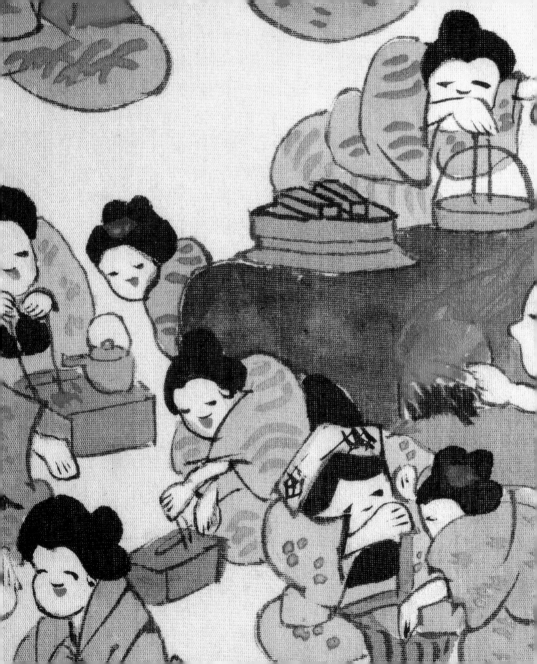

Apricot Bars

Apricot Bars are made from dried apricots, of the same genus as the *ume*, the Japanese apricot. A family favorite, these apricot bars often appear with me at events to which I am invited. In fact, they are most likely the reason why I am invited. They were served at my first Festival of Fibers lecture series for the College Women's Association of Japan given nearly 20 years ago. Like Okame, I am not much for committees, but I did take the recipe and run. I have been baking them ever since.

⅔ cup dried apricots
½ cup soft butter
4 tbsps granulated sugar
1⅓ cups sifted all-purpose flour
½ tsp baking powder
½ tsp salt
1 cup brown sugar, packed
2 eggs, well beaten
1 tsp vanilla extract
⅔ cup chopped walnuts (optional)
Confectioners sugar

Rinse apricots, cover with water. Simmer 15 minutes or until soft. Drain, cool, chop. Heat oven to 180°C (350°F). Grease 23cm (8 in.) square baking pan. Mix butter, granulated sugar, and 1 cup flour until crumbly. Pack into pan. Bake 25 minutes or until light brown. Sift remaining ⅓ cup flour, baking powder, and salt. In large bowl gradually beat brown sugar into eggs. Mix in flour mixture, then vanilla. Stir in apricots (and walnuts). Spread over baked layer. Bake 20 minutes or until done. Cool in pan. Cut into 32 bars. Then sprinkle with sifted confectioners sugar.

アプリコットバー（干しあんずの焼き菓子）

材料と下ごしらえ

1) 干しあんず2/3カップと水をお鍋に入れ、煮立ってきたら火を小さくして
 15〜20分程、あんずが柔らかくなるまで煮る。冷めたら荒くみじん切り
 にする。

2) バター　1/2カップ（やわらかくしておく）
 グラニュー糖　1/4カップ
 小麦粉　1カップ（ふるっておく）

3) 玉子　2個
 三温糖　1カップ
 小麦粉　1/3カップ
 ベーキングパウダー　小さじ1/2
 バニラ　小さじ1/2（混ぜておく）
 くだいた胡桃　1カップ（好みで）

作り方

2) の材料をよくかき混ぜたら焼き皿にしきつめる。180度のオーブンで約25分、
焼き色がつくまで焼く。

その間に3) の材料をあわせる。玉子を大きめのボールに入れ少しかき混ぜ、三
温糖をいれてさらに混ぜる。少しもったりしてきたら小麦粉とベーキングパウダー
をあわせたものを振りいれ、ゴムべらでさっくり混ぜる。1) のあんずを入れて
かき混ぜ、バニラを入れる。それを焼きあがった2) の上に流し入れ、平らにの
ばす。オーブンに入れ約20分焼く。竹串をさしてみて、なにもついてこないよ
うだったら、出来上がり。

冷めたら一口大に切り、粉砂糖を上に振り掛ける。

（注）日本のオーブン180度＝外国のオーブン350度
30cm×20cmくらいの焼き皿1個分。小さいものだったら2個分の分量。

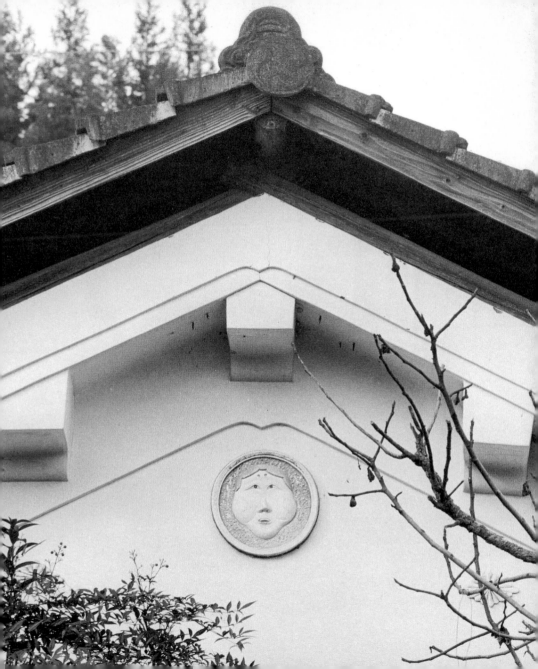

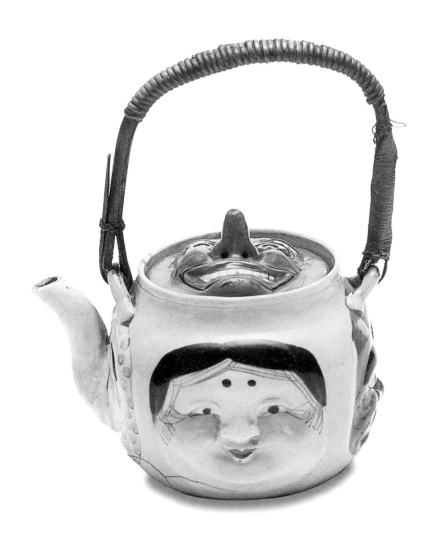

Grandmama's
out drinking—
ah! the moonlight!

FOOD FOR THE SOUL

The soul requires care and feeding as surely as the body. Nourishment must be spiritual as well as physical, and what better source of energy than a cup of joy, a platter of laughter? Play, games, toys—all fuel the heart and fill the spirit. They are as essential to your well being as food and drink.

Otafuku is a tutelary power in the world of play, of playfulness and whimsy, of delicious nonsense. She is the essence of the energy that gives us ease of heart, that brings brightness to shadows. Her icon on a dish or cup, on a kite or figurine, or on a bit of culinary creativity reminds us that simple delights are the most restorative.

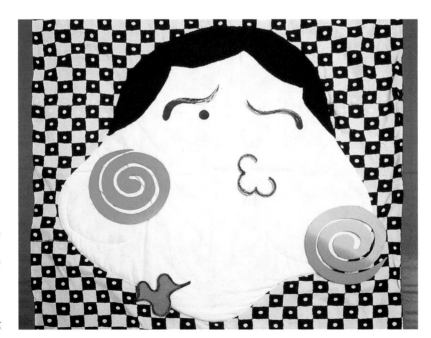

心の糧

心の糧とはよくいったものです。良いたべものが健康な身体をつくりあげるように、心にも豊かな糧が必要です。特に楽しみや笑いは私達の健全な暮らしには欠かせない活力の源です。美味しい食べ物に出会うのが楽しみであるように、人間らしく生きるには、たまにはゲームやおもちゃで遊ぶ……人生にはそんな遊び心も必要です。

おたふくは、お茶目で戯れ事が大好きな遊びの名人。いつも私達を笑いの渦に巻き込み、私達の日常生活を陽気に転ずるエネルギーを与え、私達の心を癒してくれます。お皿やマグカップ、凧や土偶に描かれたおたふくさんの絵をみかけると、私は元気が出てうれしくなって、思わず微笑んでしまいます。

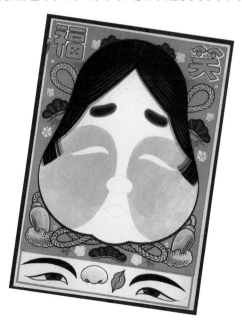

Such a beauty

making fast work

of a rice dumpling

OKAME SUSHI

This makes one large Okame.

Cook three cups of Japanese pearl rice with a lesser amount of water so that it cooks fairly hard. Dissolve 3 tablespoons sugar in 3 tablespoons of rice vinegar. Drizzle sweet vinegar over hot rice and mix vigorously with a sidewise action of a rice paddle. Take care not to smash and crush the rice. Add thinly sliced cooked carrot, shiitake mushrooms that have been braised in slightly diluted and sweetened soy sauce, and julienne strips of thin egg sheet. Shape rice into a Okame face (see photo). Make her hair out of finely julienned nori seaweed, and cut out nori shapes for eyes, eyebrows, and nose. Use a tiny piece of cut red pickled ginger for her mouth, and circles of finely chopped red pickled ginger for her cheeks.

Eat straightaway, before the nori gets soggy.

五目ちらし

材料

米：3カップ

にんじん：だしと砂糖で煮る。

しいたけ：甘辛く煮る。

ハス：だしでサッとゆで、酢と砂糖に漬ける。

竹の子：だしでサッと茹でる。

玉子：だしと砂糖を入れ、薄く焼く。

のり、紅しょうが：少々

お米の他、野菜は早めに煮て、冷ましておく。

お寿司をおたふくの形に作り、表面に白飯を薄くのばし、
その上におかめの顔をつける。

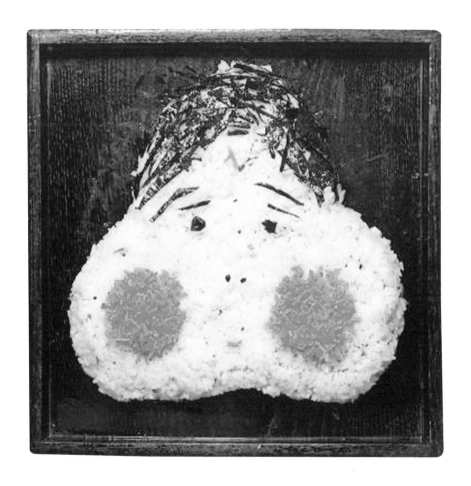

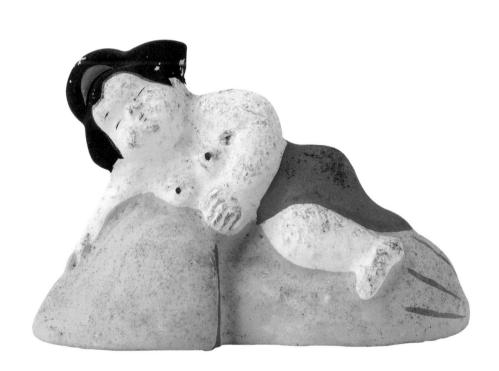

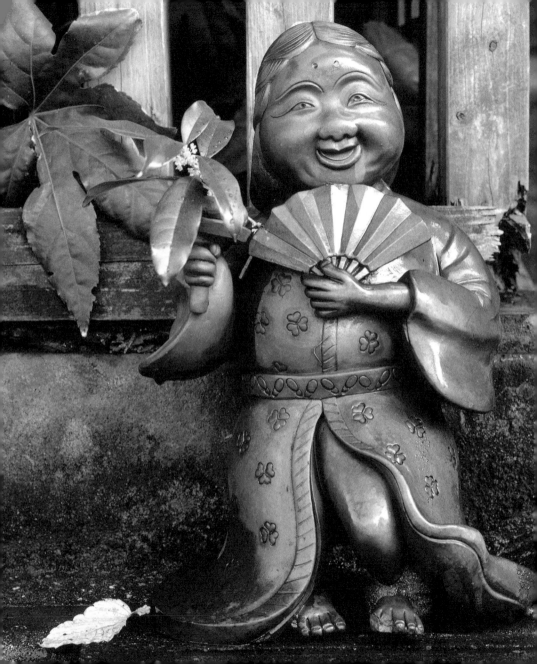

A Living Okame

On the busiest weekend of the summer, the stream of visitors was constant—ten one day, peace and quiet the next, and then a string of unexpected people all day long the next day. A lovely young woman, Yoko Murata, a fellow collector and scholar, and her family of ten suddenly appeared without warning at our not easily found old farmhouse in the mountains. Reluctantly they came in. Politely they refused whatever I tried to offer. I showed them around the house and the antique indigo textiles, some of which had come from their shop. Before I had even served them a cup of tea, they looked around quietly and with great interest, observing the textiles, antiques, Okame masks and images. But they took their leave as suddenly as they had arrived, not wanting to disturb my sleeping husband. I was mortified that they left so soon, three generations of them—the grandmother, her daughter, her brother and his wife, and a number of children.

After they had left, and I had said goodbye, something made me walk down the hill to see them off at their car. Grandmother, quite invitingly and mysteriously said, "We have Okame in the car." What could she mean? How could she possibly have Okame in the car? A mask, perhaps? Some pieces of fabric? With my curiosity rising and after a long pause, one of the younger women reached into the car and brought out her pudgy, pink, smiling, red-and-white gingham-check-dressed baby daughter, just awakened from sleep. Surrounded by family, friends and even strangers she was a bundle of smiles and at four and a half months a living Okame! True to form with her fat cheeks, her quick laughter, her charm, and irresistible in every way.

生きているおたふく

私達夫婦で過ごす夏の別荘の週末は、一度に10人ものお客さまを迎えたかと思えば、誰も訪れる人がなく静かに過ごしたり、本当に様々です。そして時には突然のうれしい訪問客もあります。

ある日、私の蒐 集 仲間で学者でもある友人の村田陽子さんが現れました。一家がドライブの途中、すこし見つけにくい私達の古い農家の別荘を捜しあてて、家族一同立ち寄ってくださったのです。私は大喜びで家を案内して、私のコレクションであるおたふくの数々や藍染（このいくつかは村田さんのお店からきたものもあります）を見ていただきました。彼女達は夫が昼寝をしていたので、起こさないようにと気遣われたのか、とにかく突然の訪問を恐縮されて、私がお茶を差し上げて引き止めようとするのを振り切り、早々にひきあげてゆかれました。

親子三世代、おかあさまと娘さん、弟夫婦に子供達、遠方から家族ぐるみでせっかく訪ねてくださったのに、私はなんのおもてなしもできず残念でなりません。玄関で「さようなら」といって一旦お別れしたのに、何故か心残りで、皆の後を追って車の止めてある場所まで降りていったのです。おかあさまが「エイミーさん、車の中に私達のおたふくがいるのよ」といわれました。おたふくが車の中に……？　謎めいたその言葉に私は好奇心をふくらませました。お面かしら？　それともおたふくの染められた古布かしら？

なんと！私の前に現われたのは若いお母さんに抱かれ、赤と白の可愛いギンガムチェックのおくるみにつつまれた赤ちゃんだったのです。お昼寝から目覚めたばかりのくったくなく笑っている生後4ヶ月半の丸まるとした赤ちゃんは、まさに生きている「おたふくさん」そのものでした。ふくよかな頬に魅力的な笑顔……。これでおかあさまがいわれた「私達のおたふく」の謎がとけたのでした。

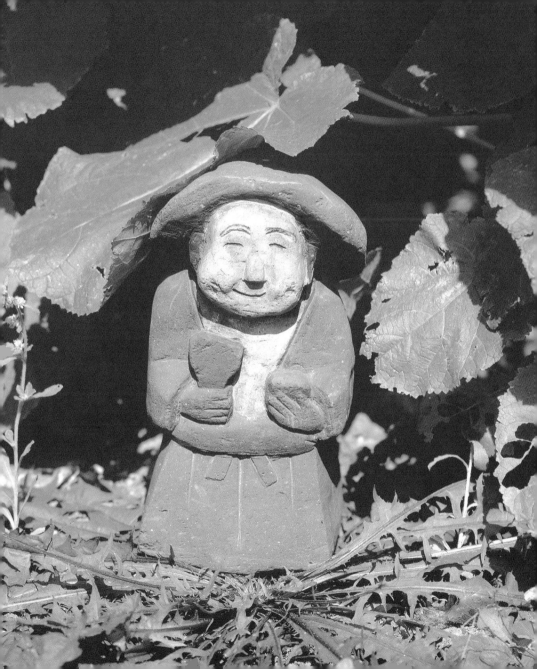

My hut

thatched with

morning glories

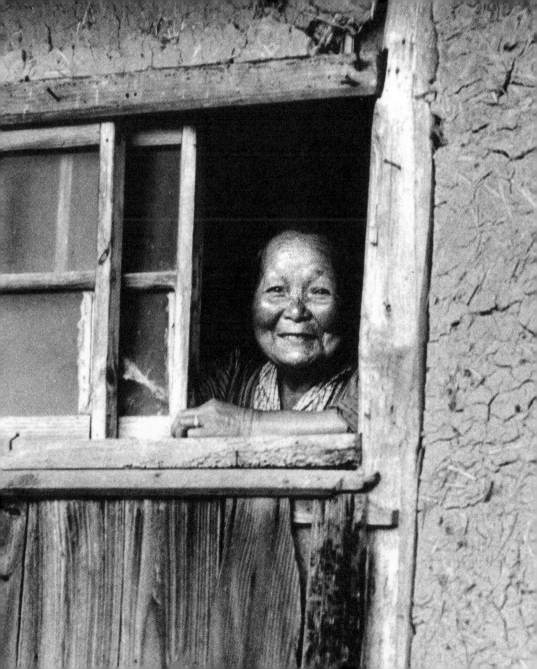

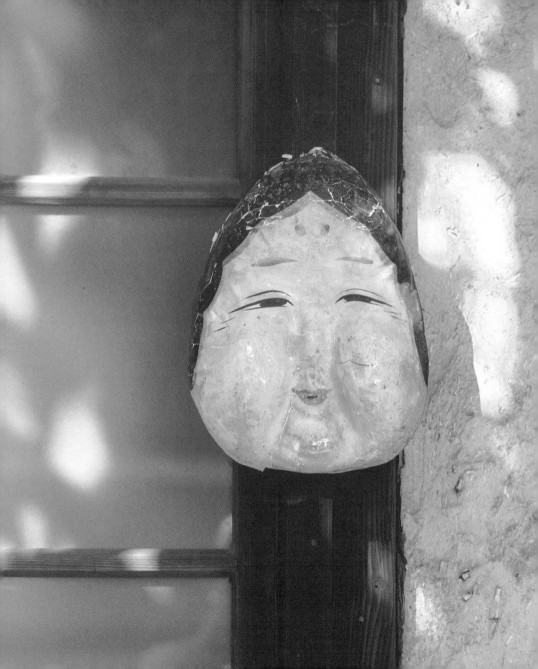

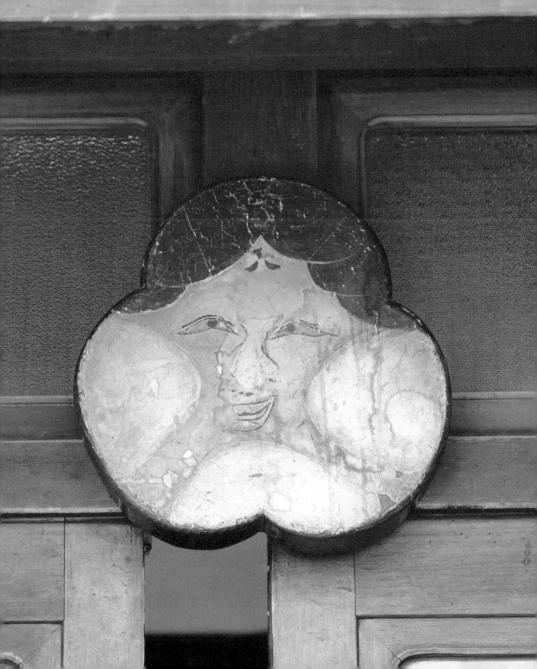

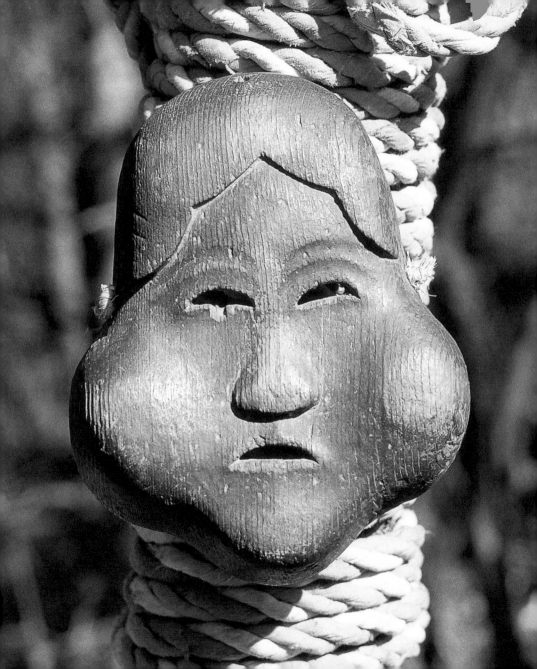

The plum tree blossoms,

the nightingale sings,

but I am alone

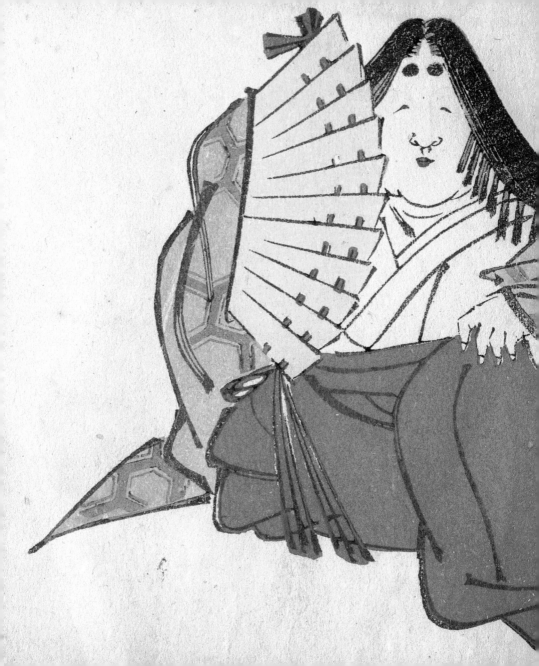

Content I sleep tonight—
wood enough for kindling
my New Year's fire

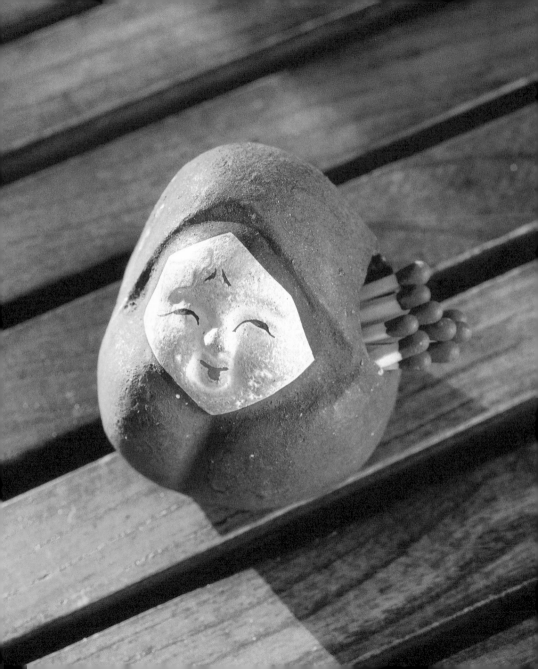

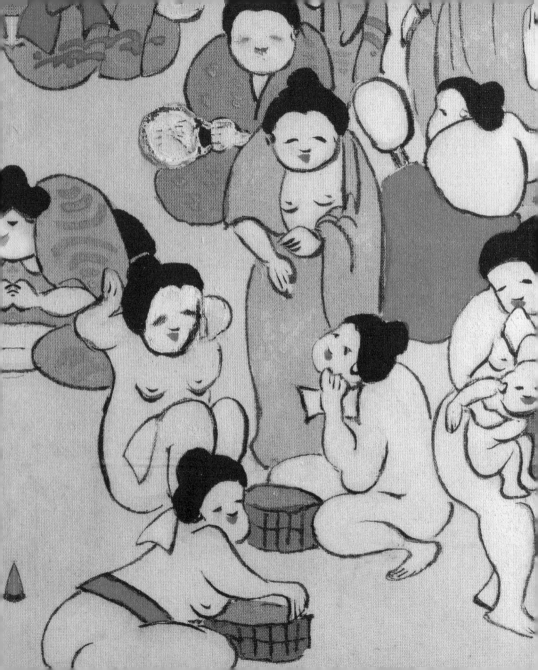

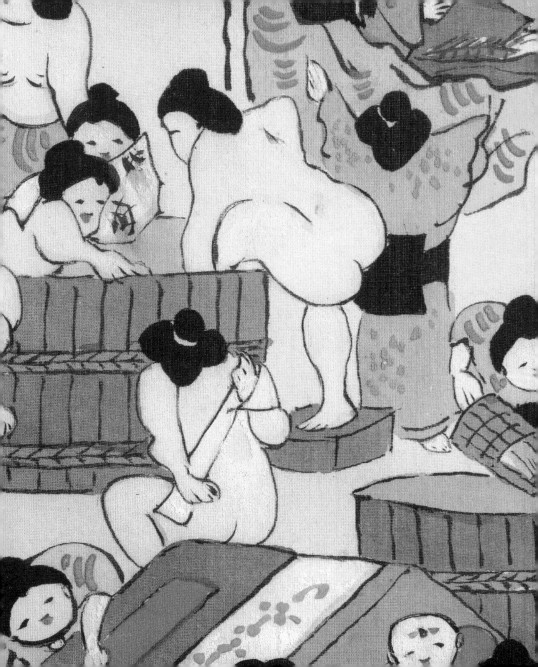

Outside, the world—

me, at home

at peace

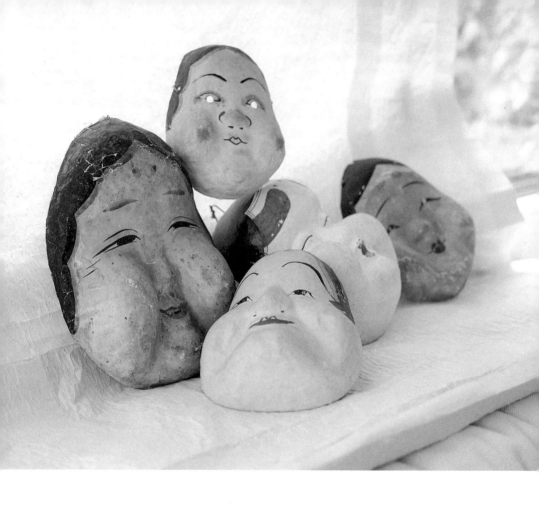

COLLECTING

The thrill, the excitement of a flea market is perhaps not felt by all, but it touches the soul of a collector. On flea market Sundays, a sharp PING goes through the body as some celestial alarm clock reaches down and plucks you from bed and urges you to rush out for the quest. There just might be a treasure. The object of your passion might be sitting there in a pile, awaiting discovery. I have no doubt that it is destiny that brings you together with the object of your affection, particularly when it is a lowly Okame.

Perfection is not what I am after. Quite the contrary! I want the lady with a run in her stocking, a smudge on her face, her hair out of place. I want an Okame I can talk to, feel at home with. I want someone I can laugh with, trade stories with, who will tell me her troubles if I tell her mine. I often find a quirky smiling lady still sitting there, forgotten in the corner of a flea market booth or in an antique shop. I sometimes have the feeling that she has been waiting for me. Usually she is the one that the dealer is not proud to show. The wallflower. Those are the ones who thrill me when I find them and delight me further when I take them home. They continue to invigorate me; I want to spend time with them.

I must confess there is also a joy in discovering something no one else has noticed, or that everyone else has left behind. That is one of the great pleasures of the flea market. I take my treasures home and arrange them for all to see on a shelf or chest. I never hide them away. They are never put away, and my family sweetly keeps quiet about the new visitors who come to live with us. Ah, the rapture of the find!

コレクション

市で掘り出しものを捜すスリルや興奮はコレクターのみが知る醍醐味です。市の
たつ日曜の朝になると、もう頭はそのことで一杯！ 目覚しなんか鳴らなくても、
天の啓示で早朝から目が覚めてベッドを飛び出し、宝を求めて市へとひたすら向
かうのです。うずたかく積まれた宝の山、その中に私に発見されるのを待ってい
るかも知れないおかめの姿が目に浮かんでわくわくします。それは大袈裟にいう
ならば、私にとっては運命の出会いとも言えましょう。

私は決して、完璧なものを求めてはいません。むしろ反対に、少々袖口が傷んだ
り、髪が乱れて、顔にしみがあるような、そんな親しみを感じるおかめに出会い
たいと願っています。おかめは私にとって、気楽に笑っておしゃべりしたり、時
にはお互いの悩みを打ち明けるお友達のような存在であって欲しいのです。

そんな彼女達には商売人もあまり注意をはらわないので、しばしば骨董屋で埃を
かぶっていたり、露店の忘れられたような隅に置かれているのを見かけます。そ
んなおかめに出会うと私は嬉しくなり、彼女達と福や喜びを分かちあうために家
に連れて帰るのです。正直なところ、わたしは誰もが気付いてないもの、誰もが
見向きもしないでいるものに価値を見いだして、蒐 集 することこそ市に通う最
大の楽しみであると信じています。

私の目によって発掘されたおかめ達は、家のテーブルや棚に飾られます。そして
家族は、私の新たなコレクションを愛で優しく迎えてくれるのです。

あー、これこそ蒐集の喜びなのです。

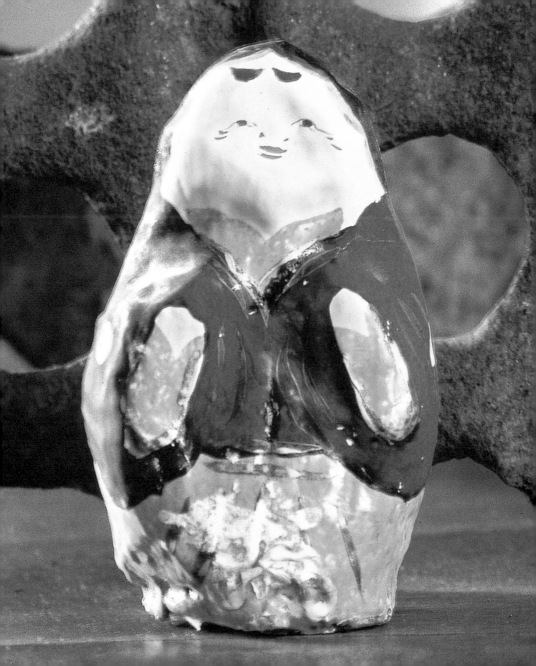

Choosing Okame

After what seemed to be a long respite outside Okame territory, I ventured out for a first Sunday of the month flea market. Having visited any number of museums, galleries and collections in the United States, I secretly hoped that my tastes had moved on to loftier places and that Okame's hold over me had diminished—i.e., that I would not keep buying her. I even desired that there might be no more interesting and unusual Okame figures or images to collect.

At the flea market there were quite a few Okame to be seen. In one little-visited corner, I found a wonderful wooden fan-shaped shop sign with a luminous and smoky-white full-cheeked face, deeply carved eyes, pursed mouth. Made with the finesse of a fine Noh mask, this Okame had an energy and magic. It pulsed with power, albeit a little frightening, and though it beckoned me, I passed it by with reluctance. What I could not leave was a set of five round carefree Okame-faced plates. There was intense economy of line and innocence in their expression. I had to bring them home. But I was not carrying enough money to pay for them. "What to do?" I asked the dealer. "Just deposit the money in my bank account when you have a chance." "What? You are giving me these plates with no deposit and without even knowing my name?" I exclaimed in amazement. "There is no such thing as a bad Okame buyer," he said. "She only attracts the good, the honest and the honorable." Pleased to be counted in that select number, I carried the five treasures home, once again stunned by the power of Okame.

At a second market the same Sunday, I found two more compelling Otafuku images; one a bottle-sized heavily glazed standing clay Otafuku, roughly rendered and colored. A somewhat sour contrast to the five lighthearted plates I had found earlier. At the same stall was a dancing Okame in the red and white costume of a shrine maiden, twirling with pink plum blossoms. Both alluring. Both tempting, I went back any number of times to have another look. (I never buy anything on the first go. I always try to leave, mull a bit, then come back for a second or third look.) On the fourth viewing, with some sadness,

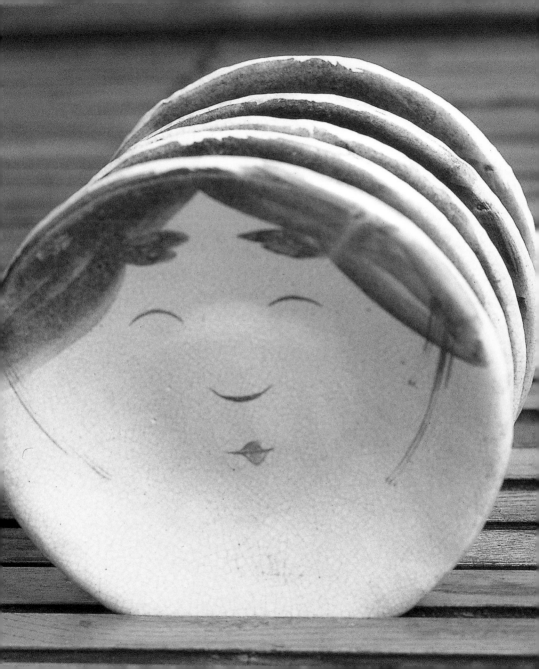

I decided I indeed could live without her. You can't possess every Okame you meet. And you usually remember the ones you leave behind. They are part of a mental collection.

Somehow I feel Okame is standing behind me as I decide, tapping me on the shoulder, advising. She is with me, my muse, inspiring my choices.

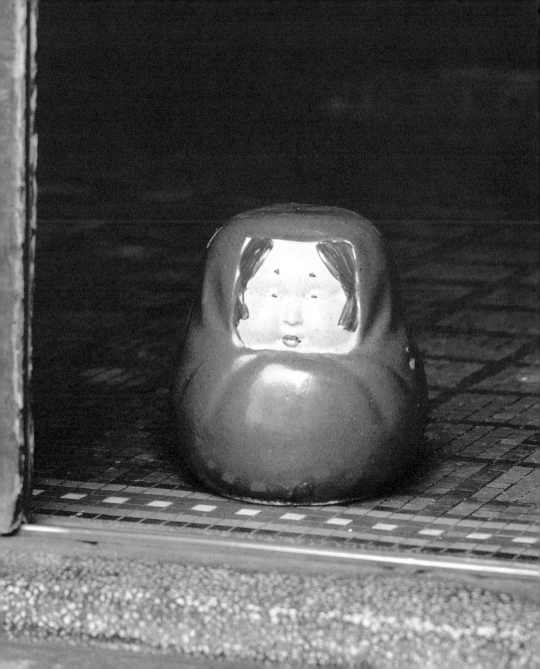

おかめの選択

しばらくの間、おかめの世界から離れていた私ですが、思いきって第一日曜に開かれる蚤の市に足を運んでみました。アメリカをしばらく旅して、美術館や画廊、そしてたくさんのコレクションに触れてきた私。審美眼も高まって、今までのように数にこだわるのではなく、本当に良いものだけを選ぼうと秘かに自分に言い聞かせていました。そしてもうこれ以上、コレクションに加えねばならないようなユニークなおかめに出会わないようにとさえ願う心境になっていたのです。

市ではそんなにたくさんのおかめが並んでいる訳ではありません。しかし、あまり人の寄り付かないコーナーで扇形のすてきな木製の看板を見つけました。そこには豊かな頬、くすんだ白い顔、能面のように精緻につくられた魅力的なおかめが彫られていました。だけど、私はこのおかめの手招きに誘惑されながらも通りすぎることに決めたのでした。そして次に私の目をとらえて離さなかったのは、なんともものどかなおかめの表情が描かれた5枚の丸皿でした。これだけは絶対買ってかえらねば……と決意したのですが、お財布を調べるとこのお皿を買うのに充分なお金を持ち合わせていないことに気がついたのです。

「お金が足りないのですが」

「ついでの時に振り込んでくれたらいいよ」「えっ？ 預かり金もなしに、私の名前も告げてないのに、このお皿を私に持たせてくれるの？」「なあに、おかめを選ぶ人には悪い人なんか居ないさ。おかめの方も正直で善人しか選ばないからね」こんなやり取りがあって、幸せな私は今日もおかめの徳にあやかり、意気揚々と5つの宝物を手に帰途についたのです。

この日曜日、次に訪れた市でふたつの捨てがたいおかめを見かけました。その

ひとつは色がついていて釉薬（ゆうやく）が厚くかかった小さな土人形で、先に見つけたお皿とは対照的なものです。同じ露店で見つけたもうひとつは、緋色と白の巫女（みこ）装束（しょうぞく）をつけ、紅梅の枝をかざして踊るおかめでした。ふたつともとっても魅力があって私を誘惑します。私は何度も行ったり来たりしながら熱い視線を注ぎました。（ちなみに私は初見で飛びついたりしません。いつもいったん離れて、思いを巡らし、時には二度も三度も戻って見直してから決めます）この時も四度目に戻った時に、ちょっと心残りはあったのですが、ついに買わない決心をしました。

心に秘めたコレクションとでもいうのでしょうか？ コレクターにとって蒐集（しゅうしゅう）し損ねたものはいつまでも記憶から消えないといいますが、私達は出会った全てのものを所有することはできないのです。私の場合、迷った時にはいつも別のおかめさんが私の背後にいて肩をトントンとたたき、一体どうするのかを教えてくれます。このおかめさんは私の蒐集の守護神ともいえるでしょう。

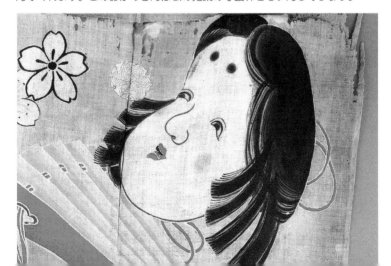

GENEROUS GINGER

I met her for the first time at the first market of the New Year at Hachiman Shrine in downtown Tokyo's Monzen Nakacho. She picked up the shiny porcelain Okame figure after I had seen it but was securing our overzealous dog to a safe place. For what seemed like forever, she fondled it lovingly, turning it over and over in her hands. It was a yellow robed, saintly faced Okame on one side and a pure and simple Fukusuke, her male counterpart, guardian of good fortune, on the other. An auspicious ceramic figure, made for export, thought the dealer, from the 1920s. Not old. Not great. But charming and certainly unique in its two-sided good fortune. The woman kept admiring the piece. I went away so she could decide on her own, and hopefully Okame herself would decide which admirer she would go home with. After a while, the woman came to me and placed the yellow Okame in my hands. "You wanted her. Please have her," she said to me. "How did you know?" I asked in wonder. Clearly I had not concealed my ardor as cleverly as I had thought. She even suggested a bargaining price to offer to the dealer. After lusting for what someone else got first, I didn't even take the time to consider whether I really wanted her or not. I just snapped her up in relief and gratitude for the generosity of a complete stranger. And I learned that the kind stranger's name was Ginger.

The next day was the last day of a three-day antique jamboree held annually at Tokyo's mammoth Big Site. An immense hall. How could you possibly find anything in all this overflow? On my way out, I chanced upon a small and elegant Otafuku figure in clay. Her face was beautiful, her flowing flowered kimono and princess-like grace made her stand apart from any of the more common Okame I had collected to date. She called to me and invited me to take her home. I did, of course.

A few steps closer to the exit I saw Ginger again. She lives in Sendai, several hours north of Tokyo, but was in Tokyo for a weekend of antiquing with her collector husband. She asked me if I had seen the large Okame a few rows

down. "What?" I said. "Where?" Knowing by now that Ginger had a nose and an eye for Okame, I followed her to a large, dynamic kneeling Okame hand-warmer with a deeply modeled face (see Contents page). Her ample form and roundness of cheek, jowl and earlobe suggested an overflow of good fortune and generosity. Her black eyes squinted with joy and fun. Slightly serious, slightly overpowering—she was another Okame chosen by Ginger, and this weekend Ginger seemed to be the handmaiden of Okame. I could only accept Ginger's generosity with joy and gratitude.

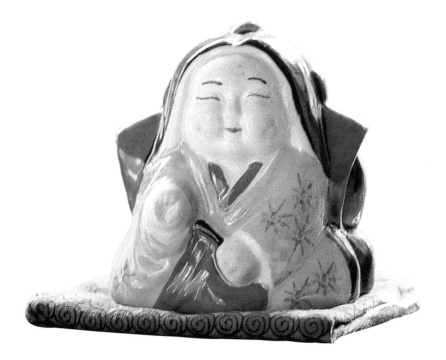

気前のいいジンジャーさん

私がはじめてジンジャーさんに会ったのは東京の門前仲町、八幡神社でひらかれ
る新年の市でした。私はある女性がおかめの陶器に興味を示して、取り上げるの
に気がついたのですが、私の犬が興奮して動き回るのでその場を離れなくてはな
りませんでした。しばらくして戻ると、その女性は余程そのおかめが気に入った
のか、まだ手の中でひっくり返しながら眺めています。それは黄色の着物を着た
おかめで、背中あわせに相棒ともいうべき福助がくっついたカップルの像です。
この二つの吉兆を象徴する焼き物の像は1920年代に輸出向けにつくられたもの
だと店の人は説明しています。たいして骨董価値があるものではありませんが、
珍しくとてもチャーミングな陶像です。

私は骨董は出会いがあって所有者のところへいくもので、人がものを選ぶのでは
なく、ものが人を選ぶのだと思っています。大いに興味をそそられたのですが、
彼女の買い物の妨げになってはいけないと思い、すこし離れて遠慮深く見守っ
ていました。しばらくして突然、彼女は私のところへやってきて、「あなたこれが
欲しかったのでしょう。どうぞお持ちになってください」と私にいわれたのです。
その見知らぬ女性がジンジャーさんでした。

私は驚きました、なるべく欲しい気持を表面に出さないようにしていたつもり
だったのに、どうやらジンジャーさんにはお見透しだったようなのです。おまけ
に彼女はいくらまで値切れるかまで、そっと耳打ちしてくれたのです。市で自分
の興味がわいた品物に出会った時には、誰かが先に手をつけると見境もなく自分
も欲しくなる気持ちがもたげてくるものですが、こうしてジンジャーさんの好意
でこの陶像をわたしのコレクションに加えることができたのでした。

その翌日は東京ビッグサイトのマンモス会場で開催される大骨董祭りの最終日で
した。とてつもなく広く混雑する会場で自分の欲しいものを見つけ出すのは至難

の技です。でも私は小さくエレガントなおかめを見つけることができ、それを求めました。この花柄の着物を着た優雅なお多福の陶像は、この大混乱する会場にあって、まるで私と出会うのを待っていてくれたかのような気がしました。

会場の出口にさしかかった時、偶然にも再びジンジャーさんにお会いしました。

彼女は仙台に住んでいて、この週末はコレクターである御主人と骨董市めぐりを楽しみに東京へ出てこられたそうです。この時、わたしははじめて気がついたのですが、彼女はどうやら「おかめ」に目が利くようなのです。ジンジャーさんは「あなた、大きなおかめを見た？」と私に聞きました。彼女の後についていくと、そこにはひざまずいたおかめの姿を形どった大きな手あぶり火鉢がありました。

それはたっぷりした形にまん丸な頬、そして吉兆あふれた、ジンジャーさんに見染められたもう一つのおかめでした。彼女は私のおかめ捜しを手助けするために、この週末の東京に現われたようなものです。私は彼女の好意に深く感謝せずにはいられませんでした。

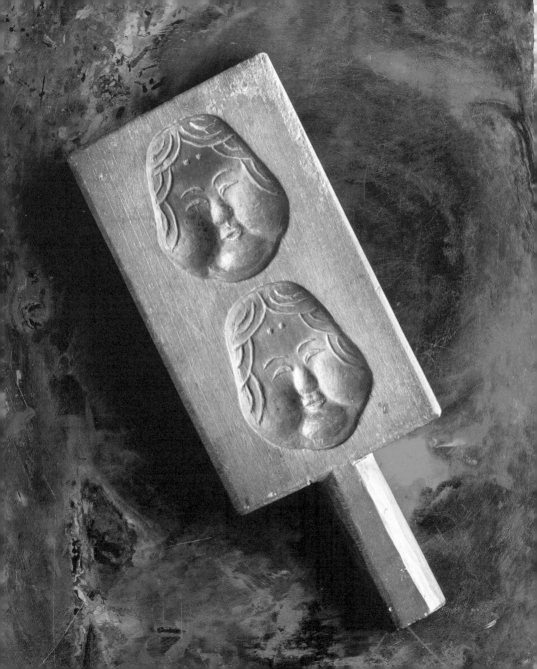

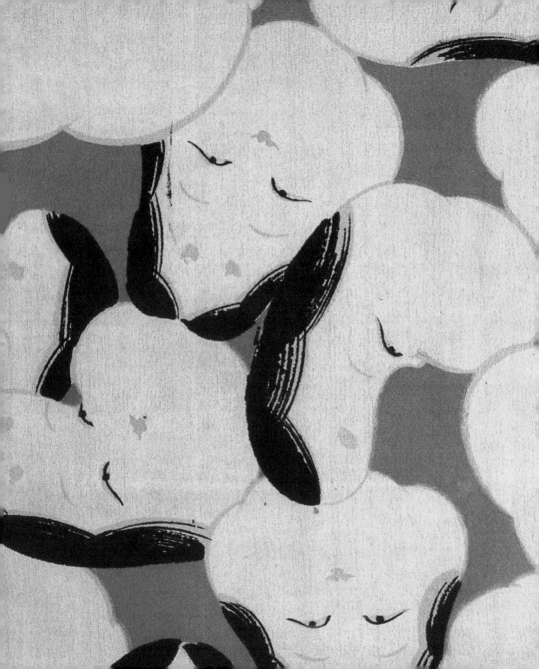

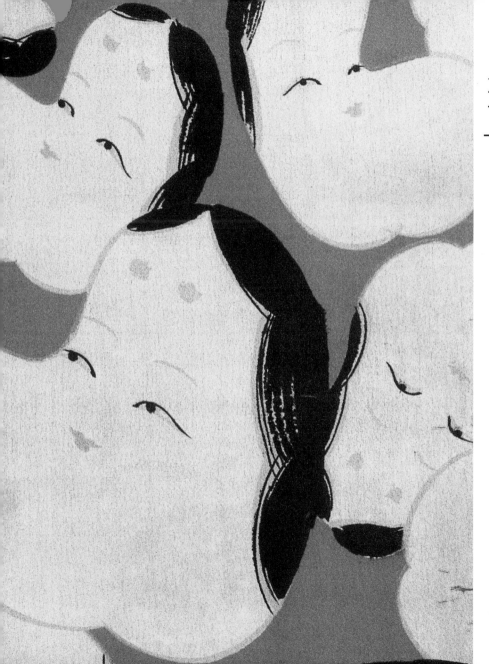

創作 ｜ Making

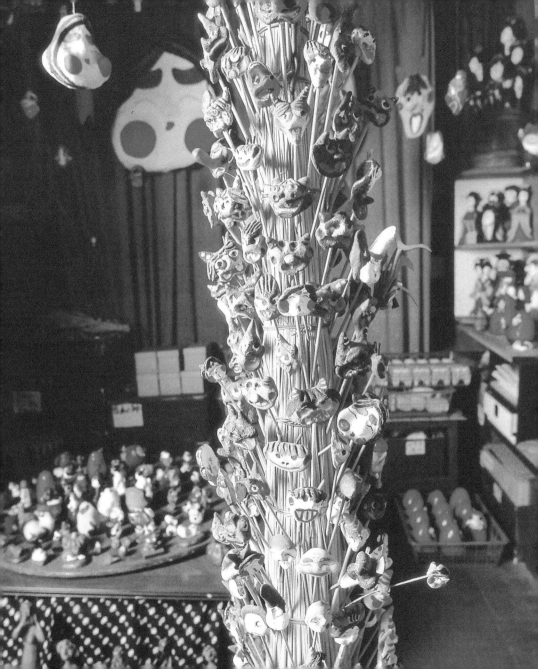

The Toymaker

At the New Year, Japanese toymakers make figures of that year's zodiac animal as well as other creations. One such toymaker is Setsutaro Matsumoto. His father had not yet decided on a name when he was born on January 29, 1904. A few days later was February 3, Setsubun, the day for exorcising evil and welcoming in the good, and the baby boy was given the name Setsutaro.

He has been making toys for over 70 years, mostly for his own pleasure. "The most fun is to make what you want to make, what you think is interesting. Things die when they are made just to sell. I make things that I enjoy."

I discovered Setsutaro Matsumoto at the annual Toy Fair held at Tokyo's Tokyu Department Store in Nihonbashi. The store's subsequent closure and demolition brought to an end an annual fair that had been held for over 50 years, regularly attended by toy collectors from throughout Japan. Setsutaro Matsumoto's amusing creations called out to me—his humorous masks and zodiac animals with their nodding heads, and his unique Okame masks. I was enchanted with their whimsical expressions: tiny pursed rosy lips on white skin with exaggerated gray swaths of eyebrows, faint black brushstroke lines for eyes, and their distinctive jutting cheeks each sporting a bright red circle. His quirky masks are of an Okame who seems to hear her own flute and dances to it. Like her maker, she does what she wants and follows her own wit and whim. I have been following Satsutaro Matsumoto for over 25 years, visiting two or three times a year, collecting whatever I could of his toys, mostly to sell at Blue and White, where his original masks and dolls are quickly snapped up by people charmed by his creations.

His house is small and enchanted. I visited on January 29, quite unaware that it was his 99th birthday. On this auspicious day he allowed me, for the very first time, to take photographs.

His home is a study in order, brimming with toys, dolls and other materials, all neatly arranged. Thick folders hold cut and folded newspaper clippings.

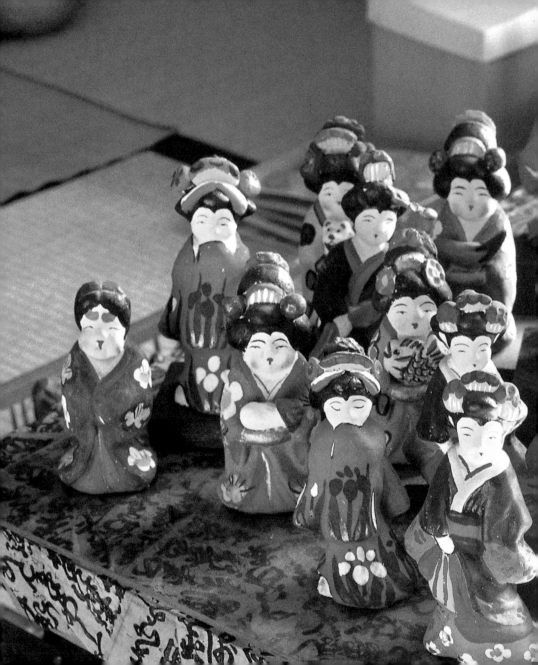

Brightly colored dolls are carefully clustered into groups or positioned on Imari plates or on tables pasted with pages of dramatic narrative (*gidayu*) scores. The impact of vibrant color, unexpected form and design and the diversity of creatures, devils, bugs, animals, female sculptures and, of course, Okame figures gives rise to a sense of joy and exhilaration.

Strung from the ceiling, hanging on walls, sitting on tables, his creations belong to a magical kingdom of delight that has sprung from an eager mind. At 99 Satsutaro Matsumoto still passionately discussed history, economics, global affairs and politics. His curiosity has never flagged, and it was this energy that led him to start making toys and to sell them to willing buyers at Tokyo's Meiji Shrine during the New Year.

His toys have the power to invoke good fortune and contain a spark of the divine. Matsumoto has endowed his creations with a vigor and essence, while giving us wings to fly to the world where they dwell. Matsumoto smiles with pleasure at seeing our delight.

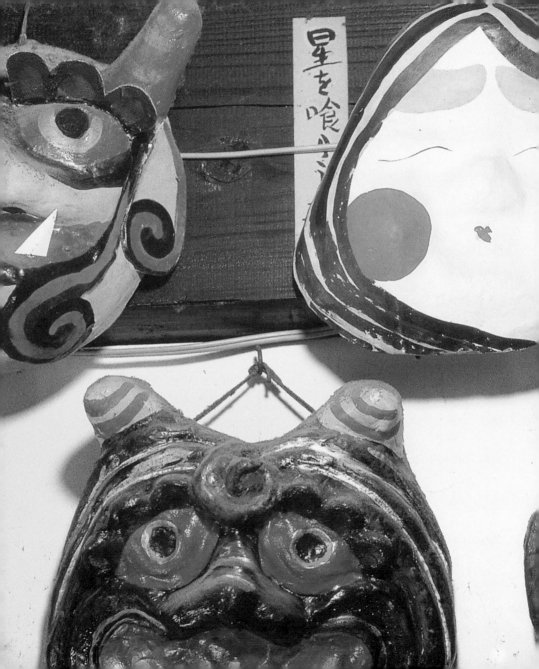
星を喰ふ

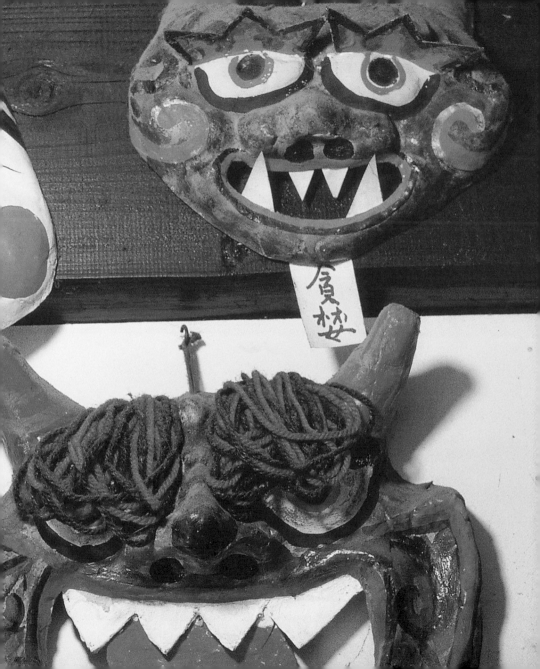

玩具職人

日本では玩具の職人が年に一度、干支にちなんだ飾り物をこしらえる慣習があります。玩具職人の松本節太朗さんは本当のお生まれは1月29日でした。しかし父上がなかなか名前が思いつかず、2月3日の節分の日になって、その日にちなみ節太朗として出生届が出されたそうです。

節太朗さんは70年もおもちゃをつくり続けてきた職人さんです。「職人というものは仕事が楽しいからやってるので、面白いおもちゃを作る秘けつは自分が作りたいものをいかに楽しんで作るかってこと。売ることなんか考えたら、もうそのおもちゃは死んでしまう」といわれます。

私が節太朗さんのおもちゃに始めて出会ったのは日本橋の東急デパートで開催されていた「新年恒例おもちゃ市」の会場でした。日本中のおもちゃのコレクターに人気だったこの催事は50年も続いたのですが、デパートが閉鎖されて建物も壊され残念ながらなくなってしまいました。

しかし、首を振る干支の動物達やユニークなおかめのお面など、奇想天外な節太朗さんの発想から生まれる数々のおもちゃは私を魅了してきたのです。特に節太朗さんの作る風変わりなおかめはすばらしいのです。小さくすぼめた口、白い肌、大袈裟な眉の剃りあと、両目のかすかな筆の線、ふっくらした両頬にはくっきりとした頬紅。それはお囃子がなりだせば、自ら奏する笛の音色にあわせて踊り出しそうに見えます。

私は実は25年間も節太朗さんの「追っかけ」をしてきました。年に2、3回は節太朗さんの仕事場を訪ねます。私自身も節太朗さんの作る独創的なお面や人形のコレクターですが、ブルーアンドホワイトのお客さんもまた節太朗さんの作品に魅せられた人達です。お店にならんだ節太朗さんの作品は人気があって、すぐに

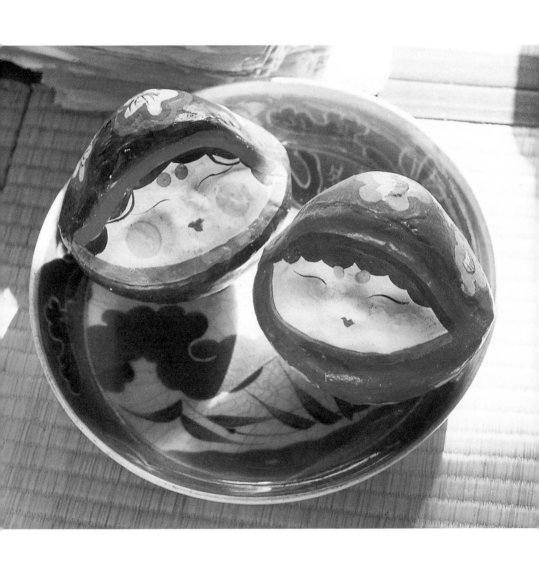

なくなってしまいます。ある年、偶然に訪ねた日が節太朗さんの99歳のお誕生日でした。このおめでたい日に、はじめてこの老職人の写真を撮ることを許されたのは実に光栄でした。

節太朗さんのお宅は狭いながらも魅力にあふれたお家です。仕事の材料、お人形、玩具などがあふれているのですが、それらは全てきちんと整とんされています。ホルダーに整理された新聞の切り抜きや色彩豊かに塗られた人形達は種類ごとに分類されて、浄瑠璃の台本で切り貼りされた机や伊万里のお皿の上で出番を待っています。多様な生き物、悪魔、虫や動物、お人形、そしてもちろん私の大好きなおかめといった仕事場を彩るすべてのおもちゃ達が訪ねる度に私をわくわくさせてくれます。天井からぶらさがったり、壁に吊るされたり、机の上にならべられた創作物はまるでおとぎ話の住人のようで、そのいずれからも節太朗さんの気合いと熱意が伝わってくるのです。

節太朗さんは99歳というご高齢なのに、歴史や経済、政治、国際時事について熱っぽく語られ、いつも話題はつきません。この好奇心こそ、節太朗さんのもの作りのエネルギーの源なのでしょう。節太朗さんの作る干支は毎年、お正月の縁起物として明治神宮で参拝客に大人気です。節太朗さんの玩具は天から授けられた幸運をもたらす力を秘めており、そして私達に創造の世界へと飛びこんでいく翼を与えてくれるのです。節太朗さんはいつも私達のそばに居られて、よろこぶ私達の姿を見て穏やかな笑顔をなげかけてくださいます。

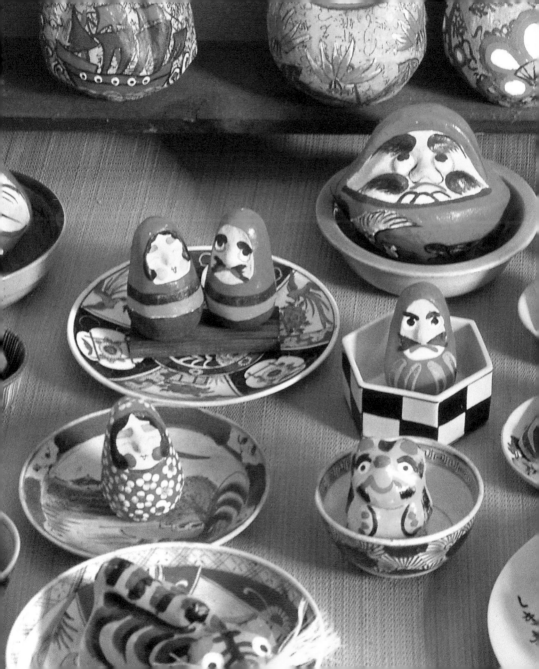

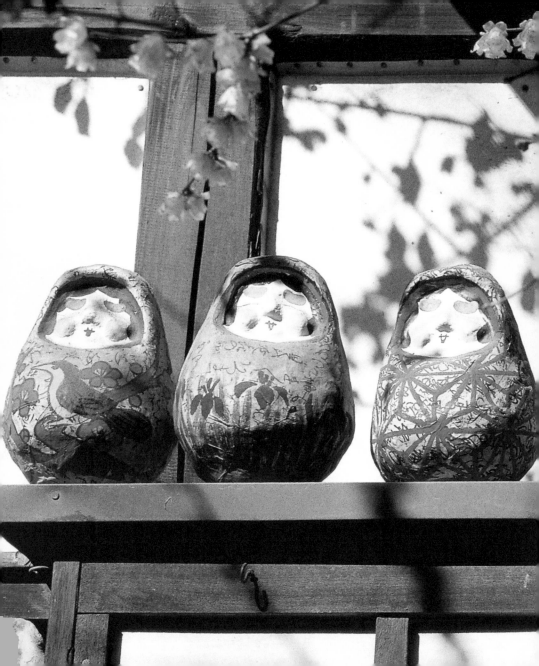

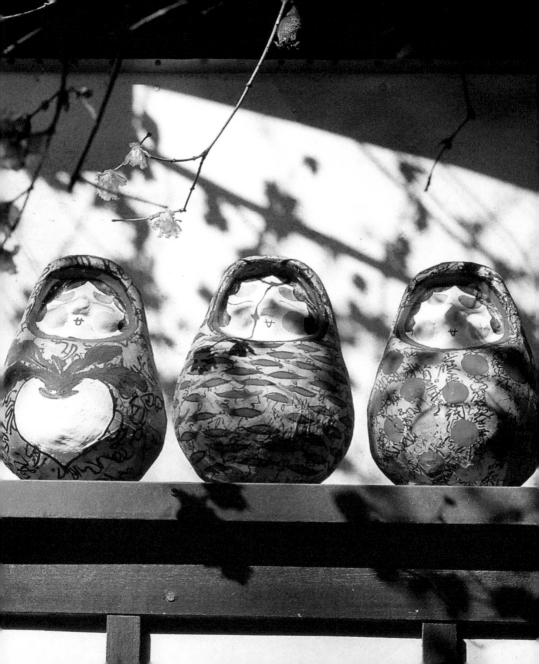

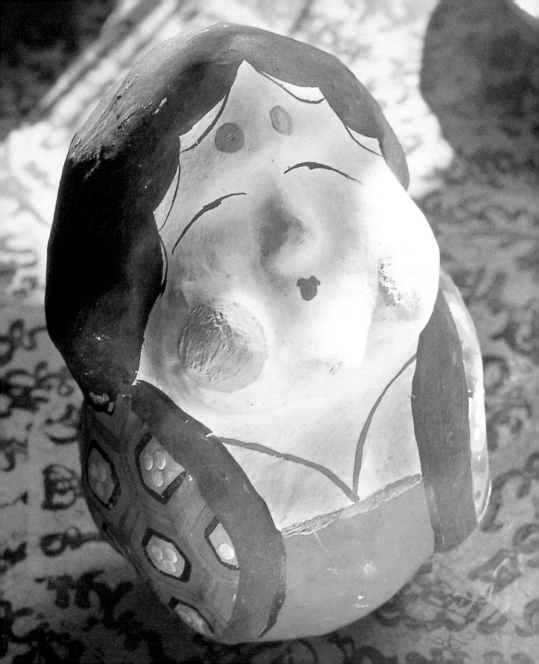

Even favorably seen—
still an odd kind of figure

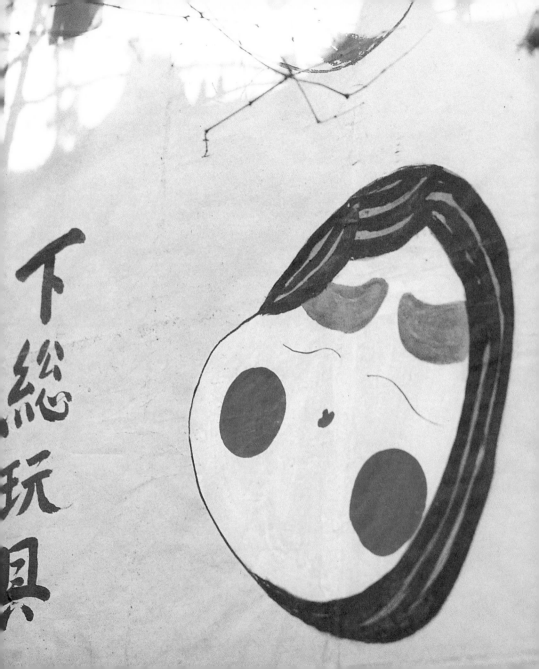

下総玩具

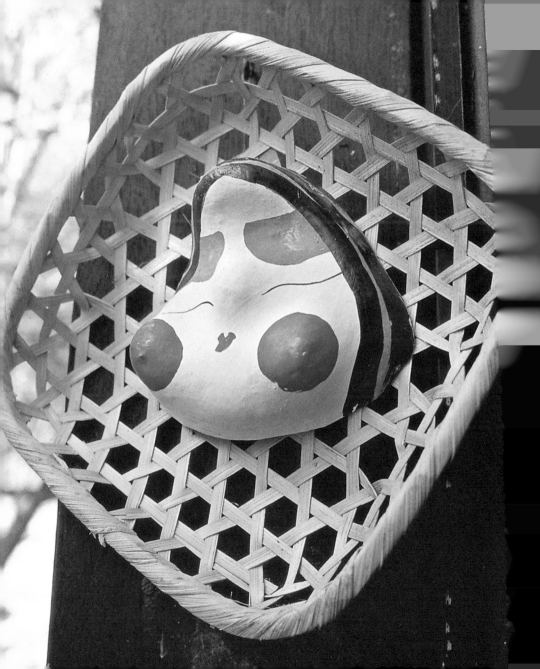

Don't go away!

you're no great singer

but you're my nightingale.

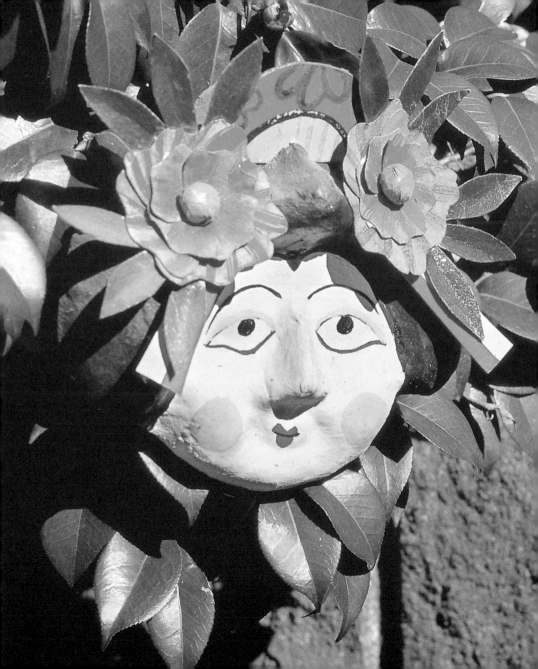

OKAME CULTURE

Japanese culture is vast and deep and multipocketed, a rich mixture of craft, art, food, drink, clothes, sweets, dance, song, prayer, architecture.... There seems to be an Okame in every pocket—on sake kegs, on measuring cups, on labels, in kimono designs. She smiles her approval on the labels of sauce bottles, she is on underwear, work gloves, stationery, stamps and sweets. Her distinctive form inspires rice crackers and all manner of Japanese confections. To most Japanese, her icon on a package is not seen so much as felt; she projects an almost subliminal message—of homey goodness, of mother's caring effort, of brightness and wholesomeness. The Otafuku image is a mark of quality, reliability and fortune. She is the goddess of good things.

Even visitors from abroad are captivated by her. An old friend came into the Blue and White shop with her husband, a banker. My friend is something of an American Otafuku herself—sweet, joyful, good natured and always upbeat. She is a natural lover of Okame, but it was her sterner and more intense husband who asked about our large Otafuku mug. Did we have any? No, I had to say, we were out. "Well, they are wonderful," he told me, "I cannot start the day without coffee from my Otafuku mug." He ordered a dozen so he could spread her joy to his friends. Okame had made another conquest! I was delighted, and, on second thought, not all that surprised. After all, she is irresistible and her message universal.

おかめ文化

日本文化は美術、工芸、衣食住にいたるまで、いろんな多くの分野が、豊かに深く混ざりあって存在するのが特徴です。おかめもまた、着物の世界、商標ラベル、升や酒樽などいろいろな分野に登場するようです。彼女の微笑みは、ソース瓶のラベル、肌着、軍手、文具、切手、お菓子、などの登録商標にも見られますし、おかめの特徴ある姿かたちはお煎餅や多くの和菓子にもたくみに取り入れられています。おたふくのしるしは優れた品質と信頼を保証し、あるいはそれらに好運をもたらしてくれる象徴といえましょう。おたふくは日本文化のなかで良いものを残す守り神なのです。

外国人のなかにも彼女に魅せられる人達がいます。私の古いお友達がブルーアンドホワイトに銀行員のご主人と一緒に訪ねてくれました。彼女はアメリカのおたふくさんとも言うべき、とっても陽気で、楽しい人柄。そして、もちろんおたふくの大ファンです。「ぼくは、おたふくマグでモーニングコーヒーを飲まないと一日がはじまらんのだよ。あのマグはあるかね？」最初に尋ねたのは、厳格で気むずかしそうに見えるご主人のほうでした。あいにく在庫がないのですよと答える私に、彼はあれはすばらしいと賞賛して、1ダースも注文してくださいました。彼の友達にプレゼントしておたふくの好運を分かちあうそうです。私はアメリカにもおたふくのファンがいることを知って、ついつい嬉しくなりました。

でも考えてみればこれは驚くほどのことではないと気がついたのです。おかめさんは世界中の誰もが好きにならずにはいられないほど普遍の魅力をもちあわせているんですもの……。

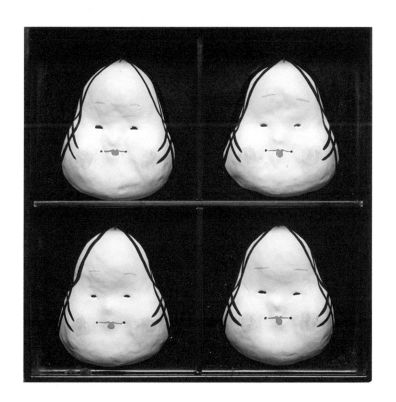

Papier-mâché masks by Shiro Tanaka; 張子面、田中司郎作

Miyajima Mingei-Kobo: 663 Miyajima-cho, Saeki-gun, Hiroshima-ken; Tel 0829-44-2090
宮島民芸工房、〒739-0500　広島県佐伯郡宮島町 663；電話 0829-44-2090

Blue and White, 2-9-2 Azabu Juban, Minato-ku, Tokyo; Tel 03-3451-0537
ブルーアンドホワイト、〒106-0045　東京都港区麻布十番 2-9-2；電話 03-3451-0537

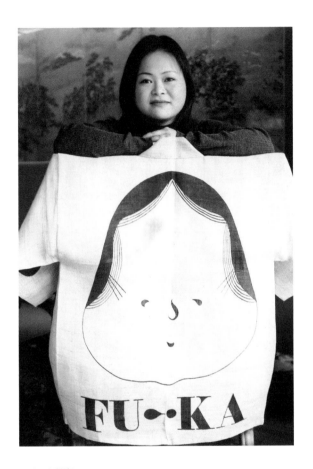

FU•KA (wheat gluten shop) 麩嘉
Hemp jacket 麻の法被
(facing page) New York Times advertisement, September 18, 1988

FU•KA : Sawaragi-cho Agaru, Nishinotoin, Kamigyo-ku, Kyoto
Tel 075-231-1584
麩嘉、〒602-8031　京都府京都市上京区西洞院椹木町上る；
電話 075-231-1584

Fu (hiragana) is 'FU' in the Japanese syllabary. (on left side of face)
It is also the name of a softly textured wheat delicacy made in Japan's ancient capital, Kyoto.
Fu (hiragana) FU is but one of the many things unique to our city:
cuisine, crafts, textiles, events and much more.
FU, a face of Kyoto
FU-ll face.
FU-ll moon.
FU-ll bloom.
FU-ll swing.
FU-ll operation.
FU-ll blast.
FU-ll blood.
FU-ll fleshed.
FU-ll grown.
FU-ll hearted.
FU-N CITY.
Imperial Palace, Castle, Shrines, Temples, KA Tea Pavillions, Tea Ceremonies, Tea Masters, Hotels, Inns, Restaurants, etc.,
Miss Fu (hiragana) Fu's Father is imported flour. (on right side of face)
Miss Fu's Mother is the well-water of Kyoto Miss Fu (hiragana) has clear smooth skin.
Miss Fu (hiragana) is a plump, likable woman. Miss Fu (hiragana) is the Goddess of prosperity, luck, well-being.
Miss Fu (hiragana) FU's smile is the smile of good fortune.
Miss Fu (hiragana) makes merry and laughs Fu Fu Fu Fu Fu (hiragana)
Miss Fu (hiragama) is made of wheat-gluten.
Miss Fu (hiragana) is a traditional delicacy of Kyoto.
FOODS Fu (hiragana)
A good companion on the road. And love to lighten life's load. Visit Kyoto and see the heart of Japan. And if you have time, drop in at Fu (hiragana) FU-KA and see real Fu being made.
Kanji FU-SION Shimondachi-uri Sagaru
MANUFACTURERS OF
CITY Nishi-no-toin Dori THE FINEST
FU-KA
KYOTO Kamigyo-ku FO FOR 160 YEARS

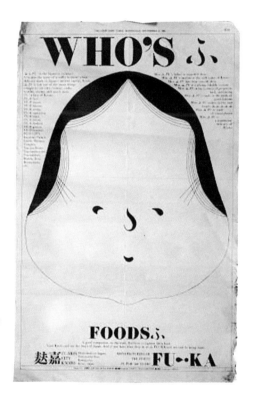

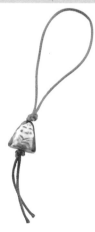

Porcelain mug, chopstick rests, amulets, cell phone strap マグカップ、箸置き、お守り、
携帯ストラップ

Blue and White, 2-9-2 Azabu Juban, Minato-ku, Tokyo; Tel 03-3451-0537
ブルーアンドホワイト、〒106-0045　東京都港区麻布十番 2-9-2；電話 03-3451-0537

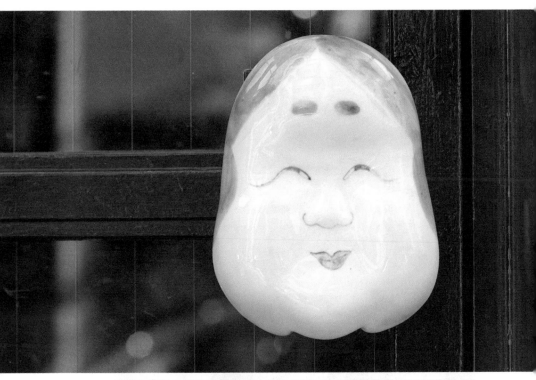

Porcelain door handle, floor tiles 陶製ドアノブ、タイル

Blue and White, 2-9-2 Azabu Juban, Minato-ku, Tokyo; Tel 03-3451-0537
ブルーアンドホワイト、〒106-0045　東京都港区麻布十番 2-9-2 ；電話 03-3451-0537

a plain woman あい traditional Japanese woman a plain woman あい traditional Japanese woman

Wrapping cloth (left); handkerchief; work gloves 風呂敷；ハンカチ；軍手

Bunkaya Zakkaten, 3-28-9 Jingumae, Shibuya-ku, Tokyo; Tel 03-3423-8980
文化屋雑貨店、〒150-0001　東京都渋谷区神宮前 3-28-9；電話 03-3423-8980

Small towel, Pin タオル、ブローチ

Blue and White, 2-9-2 Azabu Juban, Minato-ku, Tokyo; Tel 03-3451-0537
ブルーアンドホワイト、〒106-0045　東京都港区麻布十番 2-9-2；電話 03-3451-0537

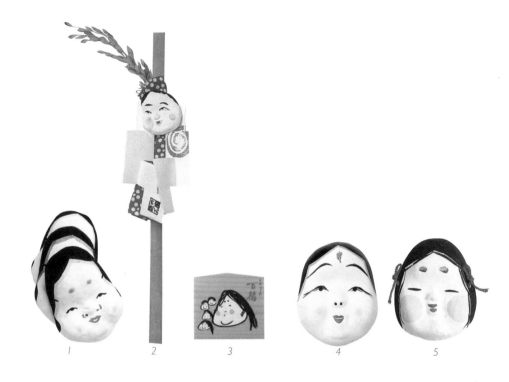

Talismans, masks お守り/ 絵馬、お面

1, 2 & 5 Blue and White, 2-9-2 Azabu Juban, Minato-ku; Tel 03-3451-0537
ブルーアンドホワイト、〒106-0045　東京都港区麻布十番 2-9-2；電話 03-3451-0537

3, 4 Senbon Shakado, Daihoonji, Imadegawa Agaru, Shichihonmatsu-dori, Kamigyo-ku, Kyoto;
Tel 075-461-5973
千本釈迦堂、大報恩寺、〒602-8319　京都府京都市上京区七本松通今出川上る；
電話 075-461-5973

5 Warakuya Okame, Hilltop Garden Meguro 3F, 2-16-9 Kamiosaki, Shinagawa-ku, Tokyo;
Tel 03-6408-8432
我楽屋おかめ、〒141-0021　東京都品川区上大崎 2-16-9 ヒルトップガーデン目黒 3F；
電話 03-6408-8432

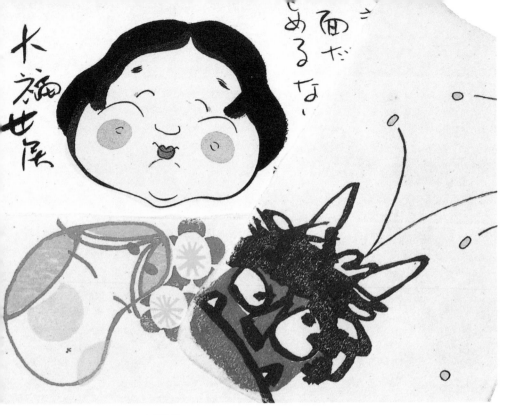

Postcards 絵葉書
Blue and White, 2-9-2 Azabu Juban, Minato-ku, Tokyo; Tel 03-3451-0537
ブルーアンドホワイト、〒106-0045　東京都港区麻布十番 2-9-2；電話 03-3451-0537

Chopsticks in wrappers, and stationery items 箸と箸入れ
*Suzando Hashimoto, Fuya-cho Higashi Iru, Rokkaku-dori, Nakagyo-ku, Kyoto;
Tel 075-223-0347*
嵩山堂はし本、〒604-8072　京都府京都市中京区六角通り麩屋町東入る；
電話 075-223-0347

*Suzando Hashimoto Ginza, New Melsa 6F, 5-7-12 Ginza, Chuo-ku, Tokyo;
Tel 03-3573-1497*
嵩山堂はし本　銀座、〒104-0061 東京都中央区銀座5-7-12、
ニューメルサ 6F；電話 03-3573-1497

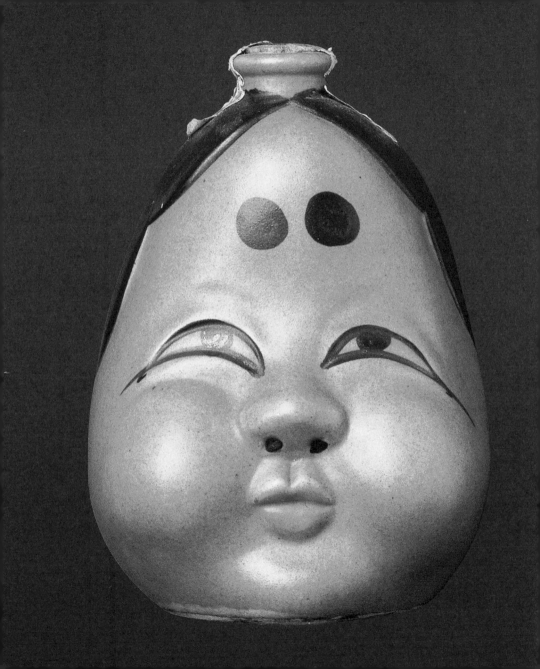

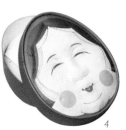

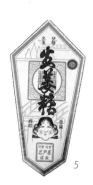

1. Shichijo Kanshundo (Egao candies)
551 Nishinomon machi, Honmachi Higashi Iru, Shichijo dori, Higashiyama-ku, Kyoto;
Tel 075-541-3771
七條甘春堂（えがお）、〒605-0947　京都府京都市東山区七条通本町東入西の門町551
電話 075-541-3771

Kabukiza, 4-12-15 Ginza, Chuo-ku, Tokyo; Tel 03-3541-3131
歌舞伎座、〒104-0061　東京都中央区銀座4-12-15；電話 03-3541-3131

2, 3 Sugar-covered beans with edible mask; box of sweets
Taneya Himure Village, Miyauchi-cho, Omihachiman-shi, Shiga-ken; Tel 0748-33-4444
たねや、〒523-8585　滋賀県近江八幡市宮内町日牟禮ヴィレッジ；電話 0748-33-4444

4 Box of sweets
Minamoto Kitchoan, 1-24-21 Chikko-shinmachi, Okayama-shi, Okayama-ken;
Tel 086-263-2651
源吉兆庵、〒702-8056　岡山県岡山市築港新町1-24-21；電話 086-263-2651

5 Ginger candy
Iwatoya, Ise Shrine, Naigu-mae, Ise-shi, Mie-ken; Tel 0596-23-3188
岩戸屋、伊勢神宮、〒516-0024　三重県伊勢市内宮前；電話 0596-23-3188

Left: Sake container, no longer made.

| Sweet bean pudding | Salty/sweet beans | Sweet crackers | Salted beans | Cracker game | Sake | Tea |

Eitaro, 1-2-5 Nihombashi, Chuo-ku, Tokyo; Tel 03-3271-7785
榮太樓總本舗、〒103-0027　東京都中央区日本橋1-2-5；電話 03-3271-7785

Ginza Akebono, 5-7-19 Ginza, Chuo-ku, Tokyo; Tel 03-3571-3640
銀座 あけぼの、〒104-0061　東京都中央区銀座5-7-19；電話 03-3571-3640

Inariya, 2 Kaido-cho, Fukakusa, Fushimi-ku, Kyoto; Tel 075-641-1166
いなりや、〒612-0806　京都府京都市伏見区深草開土町2；電話 075-641-1166

Mametomi Honpo, Shichijo Agaru, Higashinakasuji-dori, Shimogyo-ku, Kyoto ; Tel 075-371-2850
豆富本舗、〒600-8222　京都府京都市下京区東中筋通七条上る；電話 075-371-2850

Ginza Akebono, 5-7-19 Ginza, Chuo-ku, Tokyo; Tel 03-3571-3640
銀座 あけぼの、〒104-0061　東京都中央区銀座5-7-19；電話 03-3571-3640

Kinokawa Shuzo (Emifuku sake), 17-4 Hajinoomachi, Isahaya-shi, Nagasaki; Tel 0957-22-5600
枡の川酒造（恵美福）、〒854-0056　長崎県諫早市土師野尾町17-4；電話 0957-22-5600

Uji-en (Okame tea), 1-4-20 Shinsaibashisuji, Chuo-ku, Osaka; Tel 06-6252-7800
宇治園（小佳女）、〒542-0085　大阪府大阪市中央区心斎橋筋1-4-20；電話 06-6252-7800

Sake bottle & keg

Good fortune sushi roll

Pancake sauce

Fermented beans

Kinokawa Shuzo (Emifuku sake), 17-4 Hajinoomachi, Isahaya-shi, Nagasaki; Tel 0957-22-5600
枡の川酒造（恵美福）、〒854-0056　長崎県諫早市土師野尾町 17-4；電話 0957-22-5600

Mitsukoshi, Ginza (take out etc.) and other department stores on February 2nd, 3rd (Setsubun)
Mitsukoshi Ginza, 4-6-16 Ginza, Chuo-ku, Tokyo; Tel 03-3562-1111
三越　銀座、〒104-8212　東京都中央区銀座 4-6-16；電話 03-3562-1111

Pancake (Okonomi) sauce, Markets throughout Japan
お好みソース、日本各地

Fermented beans (Natto), Markets throughout Japan
納豆、日本各地

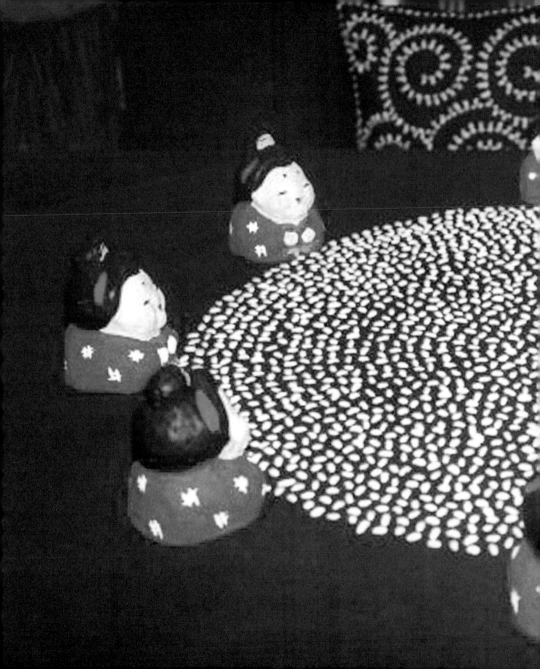

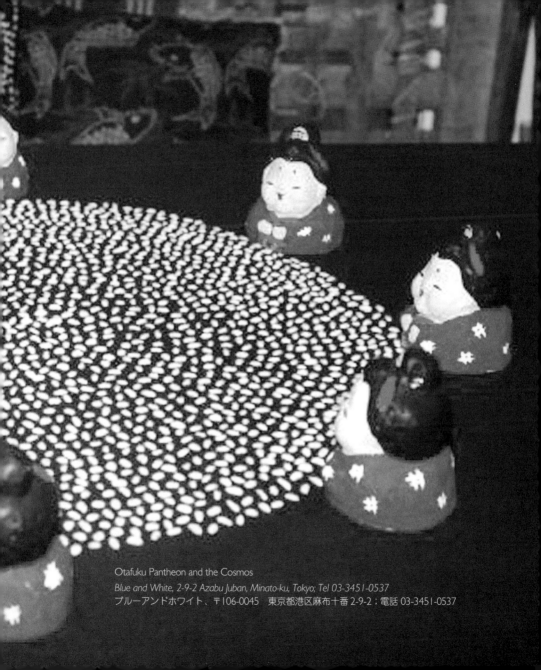

Otafuku Pantheon and the Cosmos

Blue and White, 2-9-2 Azabu Juban, Minato-ku, Tokyo; Tel 03-3451-0537

ブルーアンドホワイト、〒106-0045　東京都港区麻布十番 2-9-2；電話 03-3451-0537

CAPTIONS

Cover "Hi me", Kyogen mask, Okura
Shukokan lacquer on wood, 15th–16th c.

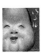

表紙、狂言面「姫」、木造彩色、15-16世紀
20.5 × 15.5 cm、大倉集古館

p. 1 Otafuku in a Boat, scroll painting, by
Kotsu Nakamura, ink on paper, 19th c.,
Courtesy of Etsuko and Joe Price Collection.

「船中阿多福図」、墨絵掛け軸、中村芳中、19世紀、
エツコ アンド ジョー プライス コレクション、
東京文化財研究所

p. 2 Clay container for burning insect repel-
lent, Imado ware, contemporary, Tokyo. ht.
15cm.

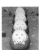

火入れ、現代、今戸焼き、東京、高さ15cm

p. 3 Okame in the Moon stamp, contempo-
rary, Blue & White.

「月とおかめ」判子、現代、ブルーアンドホワイト

p. 4 Detail of hand towel (tenugui) at
Senbon Shakado, Kyoto, contemporary

手拭い部分、現代、千本釈迦堂、京都

p. 5 Contents page: Ceramic hand warmer,
early 20th c. ht. 23 cm.

目次：陶製手あぶり、20世紀初頭、高さ23cm

pp. 6–7 Celebrating section title: printed
silk underkimono, 1920s or 1930s.

「寿ぎ」章とびら、襦袢、型染、絹、1920~30年代

p. 8 Advertisement for Fuku Sakazuke sake.
Tipsy Otafuku dancing in a lacquer sake cup,
probably early 20th c.

「福盃印」、お酒の広告、ほろ酔いのおたふくが踊る姿、
漆盃、20世紀初頭か。

p. 11 Cover of blindfold game, paper, mid
20th c. ht. 23 cm.

福笑い表紙、20世紀半ば、23 cm

pp. 13–15 100 Happinesses, scroll painting
by Masahiro, color on silk, 19th c. 113.7 x
42 xm. Courtesy of Etsuko and Joe Price
collection.

「百福図」、掛け軸、雅煕、絹本着色、19世紀、
113.7×42cm、エツコ アンド ジョー プライス
コレクション、東京文化財研究所

 p. 17 Woodblock matchbook cover, probably early 20th c.

木版画マッチ箱、20世紀初頭

 p. 18 Clay figure with stylized bamboo/pine/plum motifs on kimono, late 19th-early 20th c. ht. 22 c. girth 22 cm.

松竹梅の着物を着たおかめ、陶像、19世紀後半〜20世紀初頭, 高さ22cm、胴回り22cm

 p. 21 Antique sake cups with Otafuku faces on the inside and demon masks on the outside, early 20th c.

古盃、おたふくが内に、鬼が外に描かれている。20世紀初頭。

 pp. 22–23 Beginning section title: Indigo cotton kasuri, probably a futon cover, 19th–20th c.

「始まり」章とびら、藍染め木綿絣、布団地、19〜20世紀

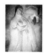 p. 24 Plaster relief on storehouse doors depicting Uzume, by Izu no Chohachi, 19th c. Yoriki Shrine, Shinagawa, Tokyo

「天鈿女命功績図」、漆喰鏝絵、伊豆の長八作、19世紀 寄木神社蔵、品川、東京

 p. 27 Plaster relief depicting Uzume, by Izu no Chohachi, 19th c. Note leaves of sacred sakaki tree in her hair and sun disk behind her. 29.2 x 40 cm. Courtesy of Izu no Chohachi Museum, Shizuoka Pref.

「天鈿女命」、漆喰鏝絵、伊豆の長八作、29.2cm×40cm、個人蔵、伊豆の長八美術館展示

 p. 29 Three faces of Okame, plaster reliefs by Izu no Chohachi, 19th century, made in earthenware bean parching pans. 32.4, 26.5, 22 cm. Courtesy of Izu no Chohachi Museum, Shizuoka Pref.

焙烙のおかめ三体、漆喰鏝絵、伊豆の長八作、19世紀、左から32.4cm、26.5cm、22cm、個人蔵、伊豆の長八美術館展示

 p. 31 Very old wooden mask, provenance and date unknown. ht. 28 cm.

古い木製おかめ面、制作地、年代不明、28cm

 p. 32 Cotton banner depicting Uzume as shrine maiden, end 19th–beginning 20th c. 285 cm.

巫女姿の天鈿女命の幟、19世紀末〜20世紀初頭、285cm

pp. 34–35 Blessing section title: printed silk underkimono, 1920s or 1930s

「祝福」章とびら、襦袢、型染、絹、1920〜30年代

p. 36 Folk painting, provenance and date unknown. ht. 25.5 cm.

民画、制作地、年代不明、長さ25.5cm

p. 37 Otafuku talismans made at Blue & White.

お守り、ブルーアンドホワイト

pp. 38–39 Votive tablet, Otatsu Inari Shrine, Kyoto, contempoary. 6 × 15 cm.

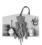

絵馬、現代、御辰稲荷神社、京都、6×15cm

pp. 40, 42 Aspects of Otafuku; three kyogen drama masks; "Hime," 15th–16th c., ht. 20.5 cm; p. 42 "Fukure," 17th–19th c., ht. 19.5 cm.; "Oto," 15th c., ht. 18.3 cm. Courtesy Okura Shukokan Museum of Art.

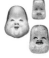

狂言面「姫」、木造彩色、15～16世紀
20.5×15.5cm、大倉集古館
上 狂言面「ふくれ」、木造彩色、17～19世紀、
19.5×14.0cm、大倉集古館 下 狂言面「乙」、
木造彩色、15世紀、18.3×14.3cm、大倉集古館

pp. 44–45 Ofuku Grilling Dumplings, ink painting on paper by Hakuin. Courtesy Iida Museum, Nagano Prefecture.

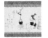

「お福団子」、紙本墨絵、白隠、制作年不明、
35.7×54.7cm、個人蔵、飯田市美術博物館、長野県

pp. 48–49 Ofuku Turning Stone Grinder, ink painting on paper by Hakuin Courtesy Eisei Bunko Museum, Tokyo.

「お福粉挽歌」、墨絵、白隠、永青文庫蔵、東京

p. 51 Bronze seated Okame, Senbon Shakado temple, Kyoto. 1979.

銅像、千本釈迦堂、京都、1979年

pp. 52, 53 Setsubun procession, priest with Okame mask, demon and Okame, Senbon Shakado temple, Kyoto

節分行事、おかめ面をつける僧侶、おかめと鬼、
千本釈迦堂、京都

p. 54 Votive tablet, Senbon Shakado temple, Kyoto, contemporary, w. 15 cm.

絵馬、現代、幅15cm、千本釈迦堂、京都

p. 55 Antique votive tablet (detail), 19th c.

古絵馬（部分）、19世紀

p. 56 Souvenir handtowel (detail), Senbon Shakado temple, Kyoto.

てぬぐい、千本釈迦堂、京都

p. 58 Plaster Otafuku face on storehouse, photograph by Yozo Fujita.

おたふく、鏝絵、藤田洋三撮影、大分県、九州

p. 59 *Plaster finial on roof tile above a store-house door, photograph by Yozo Fujita.*

 瓦、藤田洋三撮影

pp. 61, 63 *Otafuku masks surrounded by felicitous symbols, mounted in winnowing baskets and on "fortune gleaning" rakes (kumade), photographs by Gorazd Vilhar.*

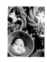 おたふく面のついた熊手飾り、箕飾り、Gorazd Vilhar 撮影

pp. 64–65 *Antique wooden mask, provenance and date unknown, set in drying rack over hearth of farmhouse against Shinto cut paper decoration. ht. 34 cm.*

 古面、木造、制作地、年代不明、34cm

p. 66 *Antique wooden mask, provenance and date unknown. ht. 32 cm.*

 古面、木造、制作地、年代不明、32cm

pp. 68–69 *Nourishing section title: printed silk underkimono, 1920s or 1930s.*

 「滋養」章とびら、絹襦袢、型染、1920~30年代

p. 70 *Kneeling Otafuku, papier-mâché, 19 c. ht. 57 cm. Courtesy of Omoshiroya Antiques.*

 正座するおたふく、張子、19世紀、高さ57cm、骨董おもしろ屋提供

p. 73 *Cover of* Shiranui, *serial noval of a daughter's revenge in 90 installments, published 1849–85, woodblock design by Kunisada.*

 雑誌「白縫」表紙、木版画国貞画、1849~85年

pp. 74–75 *Porcelain dishes, underglaze cobalt and overglaze enamels, late 19th-early 20th c. various sizes.*

 皿、磁器、19世紀末~20世紀初頭、各種色々な大きさ

p. 76 *Clay bell, Otafuku in the form of Daruma, who pops back up when pushed over, early 20th c. ht. 14 cm.*

 姫だるま起き上がりこぼし、磁器、20世紀初頭、高さ14cm

p. 78 *The plum sisters. Porcelain dish with transfer work design in underglaze cobalt and manganese, probably early 1900s. diam. 14 cm.*

「梅三姉妹」、磁器皿、印判、20世紀初頭、直径14cm

p. 81 *Bobbing headed pumpkin, papier-mâché toy, mid 1900s. ht. 13 cm, diam. 18 cm.*

 かぼちゃ張子、20世紀半ば、高さ13cm、幅18cm

p. 83 Indigo cotton kasuri, futon cover, probably 20th c.

布団絣、藍染め、綿、20世紀

p. 85 Welcoming Otafuku, clay folk toy, 19th c. ht. 16 cm.

「招きおたふく」、土鈴、19世紀、高さ16cm

pp. 86–87 Cooking, detail of 100 Happinesses scroll, painting on silk, 19th c. 174 x 52 cm.

「百福図」部分、絹本　軸、19世紀、174×52cm

p. 88 Porcelain tiered box for everyday use, overglaze enamel decoration, 1930s or late 1940s. ht. 25 cm.

重箱、磁器　色絵、1930~40年代、高さ25cm

p. 91 Plaster relief on storehouse wall, Kyushu, photo by Yozo Fujita.

おたふく、鏝絵、19世紀、藤田洋三撮影、大分県、九州

p. 92 Porcelain sake server with Otafuku and long-nosed demon (tengu) faces. Otafuku is sometimes paired with the tengu, a clear sexual symbolism. 20th c. ht. sans handle 9cm.

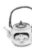

おたふくと天狗の酒器、磁器　色絵、20世紀、本体9cm

p. 93 Tipsy Otafuku sake cup (note pink around eyes), porcelain with overglaze enamels. ht. 4.3 cm., diam. 9 cm.

ほろ酔いおたふく酒盃、磁器　色絵、高さ4.3cm、直径9cm

p. 94 Blindfold game, cloth and paper, contemporary.

福笑い、布と紙、現代

p. 95 Blindfold game, paper, probably late 19th c.

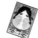

福笑い、紙、19世紀

p. 96 Blindfold game, paper, probably late 19th c.

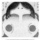

福笑い、木版画、19世紀

p. 99 Okame sushi, rice, pickled ginger, nori seaweed, sushi art by Mitsu Minowa.

おたふく寿司、米、生姜、海苔、箕輪みつ作

p. 100 Old kite from Shikoku with repairs. 78.5 x 69 cm.

古凧（修復有り）、四国、78.5×69cm

p. 101 Okame dreams, ribald papier-mâché toy. length 13 c.

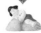

夢見るおかめ、張子、長さ13cm

pp. 102–03 Living section title: *Indigo cotton kasuri (detail), probably early 20th c.*

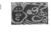

「生活」章とびら、紺、藍染め綿絣（部分）、昭和初期

p. 104 *Ceramic (roof tile) figure with fan. ht. 45 cm.*

扇を持つおたふく瓦、高さ45cm

p. 107 *God of the Rice Fields, stone, Oita, Kyushu, early 20th c. ht. 14 cm.*

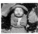

田の神様、石、20世紀、大分、九州、高さ28cm

p. 109 *Otafuku in a window, Oita, Kyushu, photograph by Yozo Fujita.*

「窓辺のおたふく」、藤田洋三撮影、大分、九州

p. 110 *Patience personified, papier-mâché mask, early 20th c. ht. 22 cm.*

張子面、20世紀初頭、高さ22cm

p. 111 *Wooden shop sign, date and provenance unkonwn. ht. 35 cm.*

看板、木造、制作地、年代不明、高さ35cm

p. 112 *Antique wooden mask, date and provenance unknown. ht. 19 cm.*

古面、制作地、年代不明、高さ19cm

pp. 114–15 *Woodblock advertisement (detail), 1st decade 20th c. 16 x 30 cm.*

木版画広告（部分）、20世紀初頭、16×30cm

p. 117 *Clay match holder, a companion of the hearth, 1930s. ht. 7 cm.*

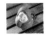

マッチ挿し（炉辺でのお供に）、陶製、1930年代、高さ7cm

pp. 118–19 *Bathers, detail of 100 Happinesses scroll, painting on silk, end 19th-beginning 20th c. 174 x 52 cm.*

「百福図」部分、絹絵、19世紀末～20世紀初頭、174×52cm

p. 120 *Cushion covers of indigo cotton kasuri, home of the author.*

クッションカバー、藍染め綿絣、作者自宅

pp. 122–23 *Collecting section title: Cotton warp kasuri, 20th c.*

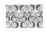

「蒐集」章とびら、紺、綿、20世紀

p. 124 *Paper-mâché and wooden masks, 19th and 20th c.*

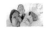

張子面、木製面、19世紀、20世紀

p. 127 *Paper-mâché figure by Fusa Miyauchi at age 92, 1960s. ht. 18 cm.*

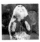

張子人形、ミヤウチ　フサ、1960年代、高さ18cm

 p. 129 Set of 5 small stoneware plates, 19th c. diam. 13.5 cm.　　銘々皿、19世紀、直径13.5cm

 p. 131 Ceramic handwarmer in the form of a *Daruma* figure, mid 1900s. ht. 25 cm.　　姫だるま火入れ、陶器、20世紀半ば、高さ25cm

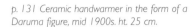 *p. 133* Kyogen drama costume, hand painted on hemp, 19th c.　　狂言装束、麻に手描き、19世紀

 p. 135 Porcelain figure with Otafuku on one side & Fukusuke on the other, 20th c. 83 cm.　　おたふく・福助人形、磁器、20世紀、高さ8.3cm

 p. 137 Ceramic bank, early 20th c. ht. 23 cm.　　貯金箱、陶器、20世紀初頭、高さ23cm

 pp. 138, 139 Wooden confection molds, probably early 20th c. 30 x 12 cm, 26 x 5cm.　　和三盆の木型、20世紀初頭、30×12cm、26×5cm

pp. 140–41 Making section title: *printed silk underkimono, 1920s or 1930s.*　　「創作」章とびら、絹襦袢、プリント、1920, 30年代

pp. 142ff Photographs in the Making section were taken at the home of Setsutaro Matsumoto in Kita Kashiwa, Chiba Prefecture.　　「創作」章の全ての写真、松本節太郎氏自宅にて撮影、千葉県北柏

 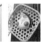 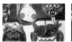 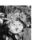

 p. 160–161 Shopping section title: *Cotton kasuri, futon cover, 20th c.*　　「買い物」章とびら、おたふく布団絣、藍染め、麻と綿、20世紀

 p. 162 Shop sign for Otafuku brand cotton batting for bedding, late 19th-early 20th c.　　おたふく布団綿の看板、19世紀末〜20世紀半ば

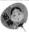 *p. 163* Matchbox cover.　　マッチ箱

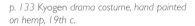 *p. 163* Festival fan from Kompira Shrine, Shikoku paper and bamboo, mid 20th c.　　祭扇、紙と竹、金刀比羅宮、四国、20世紀半ば

 p. 163 Bag for Otafuku brand cotton batting for bedding, late 19th-early 20th c. 75 x 55cm.　　おたふく布団綿の袋、19世紀末〜20世紀半ば、75×55cm

 p. 163 Vintage hand towel.　　てぬぐい、ヴィンテージ

Appreciation

My deep appreciation to those who have helped create this book.

My family—Mia, Jef and Ruby, Saya, Tai, Toshi, and especially Yuichi

Izumi Nishizawa and the ladies of Blue & White
and Mitsu Minowa
Heartfelt gratitude to Sumiko Enbutsu for researching, advising and bilingual editing.
Hide Ishiguro
Toshio Sekiji
Nobuji Ito
Mariko Yamaguchi
Joe D. Price
Margaret Price
Nancy Ukai Russell
Yoshihiko Okura
Katharine Markulin
Tadashi and Kazuko Morita
Senbon Shakado
Shoji Kobori of FU*KA!
Ute Oligschlaeger and Guido Zavagli
Sakurako Ushiyama

And to all the others who gave form to this book.

Editor: Kim Schuefftan
Design: Sophie Gaur
Japanese Translation: Hiroyuki Shindo
Japanese Editor: Kazumi Yoshida

PHOTO CREDITS

Yozo Fujita, *pp. 58, 59, 91, 109*
Eisei Bunko, *pp. 48, 49*
Iida Museum, *pp. 44–45*
Okura Shukokan Museum, *cover, pp. 40, 42*
Etsuko and Joe Price Collection, *pp. 1, 13–15*
Ministry of Cultural Affairs, *pp. 1, 13–15*
Omoshiroya, *p. 70*
Gorazd Vilhar, *pp. 61, 63*
Udo and Tomiko Wiedner, *p. 168*
Yuri Sato, *pp. 172, 173*
Ute Oligschlaeger, *photo of author on jacket flap*
Author's snapshots, *pp. 51–53, 99*

感謝

この本を書くにあたってお世話になった皆様に感謝します。

私の家族、美朝子、ジェフとルビー、早弥子、泰一郎、寿之助、特に夫、祐一

西澤泉とブルーアンドホワイトの皆さん

箕輪みつ
圓佛須美子の適確なアドバイスに感謝します。
石黒ひで
関次俊雄
伊藤伸司
山口まりこ
ジョー D プライス
マーガレット プライス
大倉美子
キャサリン マークリン
森田直、和子
千本釈迦堂
麩嘉の小堀正次
ウテ オリグシュレーガー、グイド ザバグリ
牛山櫻子

そして、この本にご助力いただいた全ての皆様に感謝いたします。

編集：　　　　キム　シュフタン
デザイン：　　ソフィー　ガウアー
日本語訳：　　新道弘之
日本語編集：　吉田和美
写真：　　　　佐藤裕

写真提供
藤田洋三、pp. 58, 59, 91, 109
永青文庫、pp. 48, 49
飯田市美術博物館、p. 44–45
大倉集古館、pp. 40, 42
エツコ　アンド　ジョー　プライス　コレクション、pp. 1, 13–15
東京文化財研究所、pp. 1, 13–15
骨董おもしろや、p. 70
ゴラーズ　ヴィルハー、pp. 61, 63
ウド＆都美子　ウィードナー、p. 168
佐藤由里、pp. 172, 173
ウテ　オリグシュレーガー、カバーの作者ポートレート
作者撮影、pp. 51–53

Sources

Izu no Chohachi Museum, 23 Matsuzaki, Matsuzaki-cho, Kamo-gun, Shizuoka Prefecture 410-3611
Matsuzaki-cho Town Office, 302-1 Miyauchi, Matsuzaki-cho, Kamo-gun, Shizuoka-ken 410-3696.

Okura Shukokan Museum of Art, 2-10-3 Toranomon Minato-ku, Tokyo 105-0001

Eisei-Bunko Museum, 1-1-1 Mejiro-dai, Bunkyo-ku, Tokyo 112-0015

The Etsuko and Joe D. Price Collection, Shin'enkan Foundation, 183 Shorecliff Rd, Corona del Mar, CA 92625-2657

Issa Kinenkan, 2437-2 Kashiwabara, Shinano-machi, Kamiminochi-gun, Nagano Prefecture 389-1305

Shoinji, Hakuin's temple, 128 Hara, Numazu-shi, Shizuoka Prefecture 410-0312

Senbon Shakado Temple (Daihoonji), Imadegawa-agaru, Shichihonmatsu-dori, Kamigyo-ku, Kyoto 602-8319, Annual Setsubun Rite, Feb. 3

Yoriki Jinja, 1-35-8 Higashi-Shinagawa, Shinagawa-ku, Tokyo 140-0002

Iida City Museum, 2-655-7 Ottemachi, Iida-shi, Nagano Prefecture 395-0034

FU*KA Sawaragi-cho Aguru, Nishi no Toin, Kamigyo-ku, Kyoto 602-8031

FU*KA, Nishiki Market branch: Sakaimachi kado, Nishiki-koji, Nakagyo-ku, Kyoto 604-8127

All haiku in the book are by Kobayashi Issa (1763–1827), a wandering port-priest born in Kashiwabara Nagano Prefecture.

伊豆の長八美術館　〒410-3611 静岡県賀茂郡松崎町松崎23, 電話 0558-42-2540
松崎町役場　〒410-3696 静岡県賀茂郡松崎町宮内 301-1, 電話 0558-42-1111

大倉集古館　〒105-0001 港区虎ノ門2-10-3, 電話 03-3583-0781

永青文庫　〒112-0015 東京都文京区目白台1-1-1, 電話 03-3941-0850

一茶記念館　〒389-1305 長野県上水内郡信濃町柏原2437-2, 電話 026-255-3741

松蔭寺（白隠禅寺）　〒410-0312 静岡県沼津市原128, 電話 055-966-0011

千本釈迦堂（大報恩寺）　〒602-8319 京都府京都市上京区七本松通今出川上る,
電話 075-461-5973；節分会　毎年2月

寄木神社　〒140-0002　東京都品川区東品川1-35-8

飯田市美術博物館　〒395-0034　長野県飯田市追手町2-655-7,　電話 0265-22-8118

麩嘉　〒602-8031　京都府京都市上京区西洞院椹木町上る,　電話 075-231-1584
麩嘉　錦店　〒604-8127　京都市中京区錦小路堺町角,　電話 075-221-4533

Bibliography / 参考文献

Edwards, Cliff, trans. Issa, *The Story of a Poet-Priest*, Macmillan Shuppan, KK, Tokyo, London, 1985

Hamill, Sam, *The Spring of My Life and Selected Haiku by Kobayashi Issa*, Shambhala, Boston and London, 1997

MacKenzie, Lewis, trans. and intro. *The Autumn Wind, A Selection from the Poems of Issa*, John Murray, London, 1957

Matsuo, Yasuaki, *Encyclopedia of Issa*, Oufuu Press, Tokyo, 1995

Norton, Joy, trans. *Furusato: Issa's Journey Home*, Nara, Dawn Press, 1987

Norton, Joy, trans. *Issa Five Feet of Snow: Issa's Haiku life*. Yaba Katsuyuki, Nagano. Shinano Mainichi Shimbunsha, 1994

Sakaki. Nanao, trans. *Inch by Inch, 45 Haiku by Issa*, La Alameda Press, Albuquerque, New Mexico, 1999

Stryk, Lucien, trans. *The Dumpling Field, Haiku of Issa*, Swallow Press, Ohio University Press, Athens, Ohio 1991

Tanahashi, Kazuaki, *Penetrating Laughter, Hakuin's Zen and Art*, Overlook Press, Woodstock, New York, 1984

Yuasa, Nobuyuki, trans. *The Year of My Life*, *Oraga Haru*, University of California Press, Berkeley and Los Angeles 1960.

俳句　小林一茶、　長野県柏原出身。　1763〜1827年。

松雄靖秋、一茶事典、株式会社おうふう、東京　1995年初版